LITERARY CHELTENHAM

David Elder

AMBERLEY

For Meg

ACKNOWLEDGEMENTS

I am most grateful to Nicola Gale at Amberley for commissioning the book. Also, a number of organisations, societies and museum, library and archive services have provided me with excellent support. My thanks in particular go to all the staff at Cheltenham Reference and Local History Libraries, Katrina Keir at the Gloucestershire Archive, Ann-Rachael Harwood and Helen Brown at Cheltenham Art Gallery & Museum, Christine Leighton, Jill Barlow and Heather Leighton at Cheltenham College Archives, Rachel Roberts at Cheltenham Ladies' College Archives, Robert Charles Whitney at Dean Close School Archives, Mrs Lucy Smith, Secretary to the Old Decanian Society, at Dean Close School, Laura Kinnear at the Holst Birthplace Museum, Pete Chadwick at The New Club, Cheltenham, Edward Gillespie at Cheltenham Racecourse, the Press Office at GCHQ, Karen Hull at The Edward Jenner Museum, Katy Hooper at the University of Liverpool, and Elaine Brazendale at Robert Gordon's College Library. I am also grateful to Claudia Seidel for help with German translation and to the following for making many helpful suggestions: James Hodsdon, Mary Moxham, Sue Rowbotham and Michael Elder. Finally, my heartfelt thanks go to my family, Meg, Rachel and Catrin, for their patience, support and encouragement.

First published 2013

Amberley Publishing
The Hill, Stroud
Gloucestershire, GL5 4EP

www.amberley-books.com

British Library Cataloguing in Publication Data.
A catalogue record for this book is available from the British Library.

ISBN 978 1 4456 1318 5 (paperback)
ISBN 978 1 4456 1327 7 (ebook)

Typeset in 10pt on 12pt Minion Pro.
Typesetting and Origination by Amberley Publishing.
Printed in the UK.

CONTENTS

CHELTENHAM

Floruit, floret, floreat!
 CHELTONIA's children cry.
I composed those lines when a summer wind
 Was blowing the elm leaves dry,
And we were seventy six for seven
 And they had C. B. FRY

Shall I forget the warm marquee
 And the general's wife so soon,
When my son's colleger acted as tray
 For an ice and a macaroon,
And distant carriages jingled through
 The stuccoed afternoon?

Floruit Yes, the Empire's Map
 CHELTONIA's sons have starred.
Floret. Still the stream goes on
 Of soldier, brusher and bard.
Floreat. While behind the limes
 Lengthens the PROMENADE.

 John Betjeman

Long live liberty, literature and chalybeate
 Springs!

INTRODUCTION

The story of Cheltenham – the place, its people, its 'golden age' as a spa and subsequent decline, followed by its revival as a centre of learning, sport and the arts and reinvention as a prosperous commercial town – is well covered in numerous books charting its history and development. However, a portrait of the town that combines fiction with fact, and poetry with prose, fused through the lenses of literary figures, artists and photographers, offers the opportunity to provide an original and endearing snapshot that is at once vivid, instructive and amusing.

Surprisingly little has been written celebrating the wealth of writing inspired by Cheltenham despite the town exerting a much greater influence across the literary landscape than its size might suggest. David Carroll provided an excellent introduction to some of the most important classical writers who visited or lived in Cheltenham in *A Literary Tour of Gloucestershire and Bristol* (1994). However, it was not until publication of *Down Cheltenham Way* (2009) by the University of Gloucestershire's Cyder Press that the town could claim the accolade of its first anthology, which spanned the work of nearly 200 writers from the time of the Domesday Book to the present day.

The intention in this volume is to present some of the most memorable images and text, as well as many lesser known, about a town that through the ages has been both greatly loved and greatly despised! Where possible, artists with a local connection, some with a national and international reputation, have also been used, further serving to illustrate Cheltenham's rich cultural heritage. Sometimes Cheltenham's portrayal has been achieved with candour and sometimes under the disguise of fictitious places such as Coltham, Handley Cross and Little Bath. Sometimes literary text has adorned its public statues, as with Captain Scott's eulogy of Edward Wilson, while at other times it has been hidden within its most secret of places, for example at GCHQ. Sometimes the descriptions of the town have been totally accurate, as exemplified by Johanna Schopenhauer: 'Cheltenham consists of a single street, at least one mile long', while at other times it has been depicted with factual inexactitude: witness one of Byron's biographers who claimed that the boy poet came to wander 'on the seashore at Cheltenham!'

Lastly, Cheltenham has inspired writers in many different, and often unusual, ways. P. G. Wodehouse, for example, discovered his Jeeves by chance, while Lewis Carroll arranged to meet his Alice here. C. Day-Lewis found his reason for entering the genre of detective story writing through a leaking roof in Charlton Kings, while W. H. Davies was arrested by the police on two separate occasions 'for that affair in Cheltenham' because he had recently travelled through 'that particular town'. Gerald Brenan, on the other hand, who himself was greatly inspired by Davies' *The Autobiography of a Super-Tramp* to such an extent that he considered becoming a tramp himself and made several trips to Cheltenham Library to read up on the subject, regretted the day when he set foot in a Pittville Street shop. Whatever the source for the writer's particular muse, one thing is certain: the distinctive character of Cheltenham has impressed a great many writers, as this anthology bears witness. Perhaps it's no surprise that the town now hosts one of the longest-established literature festivals in the country.

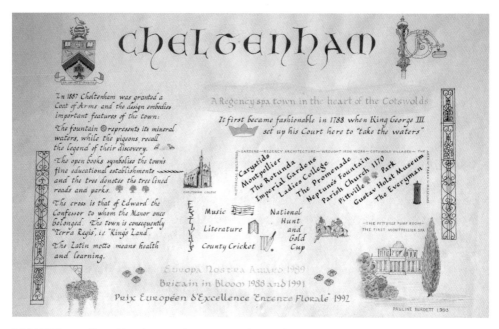

J. M. W. Turner (from *Travel Diary of a Tour in Wales*, 1792)
Cheltenham is a clean small place ... There is a formality in the whole scene that is not pleasant.

Thomas Carlyle (from a letter to his wife, 23 July 1843)
We saw only the roofs and steeples of Cheltenham; quite enough for me.

Matthew Arnold (from a letter to his mother, 25 April 1855)
I should like very well to be going to Cheltenham now ... to stay a fortnight in that very cheerful place, for it is not now the season, and one is not overwhelmed with people, and Cheltenham itself and the country about it is as pleasant as anything in England.

U. A. Fanthorpe (from *Down Cheltenham Way*, 2009)
Over the years, Cheltenham has had to suffer a variety of confusing/unhappy/misleading identities. In certain unenlightened circles it is still thought of as the place where ex-colonial officers go to die ... crusty old colonels, fading spinsters, afternoon tea and general depression. The very word 'Cheltenham' was enough to conjure a world-full of Wodehousian maiden aunts, a useful short-hand for the most conservative and respectable of backwoods.

George Orwell (from *The Road to Wigan Pier*, 1937)
Who is there who has not jeered at the House of Lords, the military caste, the Royal Family, the public schools, the huntin' and shootin' people, the old ladies in Cheltenham boarding-houses, the horrors of 'county' society, and the social hierarchy generally? To do so has become an automatic gesture. You notice this particularly in novels.

Hugh Casson (from 'Cheltenham: a Regency Town', *The Geographical Magazine*, February 1943)
But behind its jerky silhouette of parapet and roof lies the other Cheltenham – a strange, silent, stuccoed, Sitwellian land of parlour-maids, épergnes and chintz, where nothing seems to stir but the leaves of the chestnut trees or a curtain twitched aside in curiosity, and no sound is heard but the tinkle of a teaspoon in a saucer and the bicycle bell of some stray errand-boy. This is the Cheltenham of the comic papers, the home of the well-worn jokes about Anglo-Indian colonels and eccentric old ladies. For some reason Cheltenham, like Wigan or Chorlton-cum-Hardy, has always been one of those places which gets a laugh.

1

PLACE

How have writers epitomised Cheltenham as a place? Some, like Cobbett and Carlyle, have expressed their disapproval. Others have resorted to making favourable – or not – comparisons with towns such as Worthing (Lee), Galashiels (Trow), and Tunbridge Wells (Goddard), while many have also heaped praise on Cheltenham. One of these praises came from the pen of Charles Dickens. 'Rarely have I seen such a place that so attracted my fancy', he wrote to his friend, the actor William Charles Macready. Dickens first visited the town in October 1859, when he gave a performance of public readings, but made more frequent visits during the 1860s so that he could visit Macready, who came to retire at 6 Wellington Square. Like Dickens, Macready was lavish in his praise for Cheltenham, commenting on its tasteful and interesting layout, its attractive surrounding hills and that its 'conveniences of all kinds equal those of London'.

Other writers have emphasised specific aspects or features in their descriptions of the town: the grandeur of its architecture, which could perhaps rival Rome or Athens (Shaw); its tree-lined streets (Flecker, Sackville); its river, which would be affronted to be called a 'brook' (Irving); the individual personalities of its caryatids (Mitchell); the memory of its smoking kitchen gardens (Beaton); the 'intellectual stimulation' of its one-way traffic system (Mitchell); its notoriously dangerous streets for cyclists (Woolf); and its antithesis to 'a den of iniquity' (Lively). The town has also been celebrated as a venue for the detective genre, most notably in M. J. Trow's stories about Inspector Lestrade, the character created by Sir Arthur Conan Doyle in the Sherlock Holmes stories, and in the Bulldog Drummond series of stories by Herman Cyril McNeile, who was educated at Cheltenham College and created a prototype figure for James Bond under the pseudonym of Sapper.

Lastly, it is worth highlighting the significance of Box Cottage to the career of Irish-born poet laureate Cecil Day-Lewis, who moved to Cheltenham in April 1930 after being appointed as a master at Cheltenham College. At first he rented Belmore House at 96 Bath Road and then borrowed £600 to buy the freehold for Box Cottage in Charlton Kings, a brick building with a Cotswold stone roof that was partially concealed behind a large box hedge, making it look like 'a sequestered, escapist kind of house for one of the new come-down-out-of-that-ivory-tower-poets'. The house itself became inspiration for his poetry, providing the subject for 'Moving In', which was published in *A Time to Dance* (1935). It also became an important meeting place for visiting poets and writers. Among the most frequent of these was W. H. Auden, who at the time lived nearby in Malvern, and who would bed himself down in Box Cottage under layers of thick coats and blankets together with a copious supply of bananas to sustain him through their intense discussions and criticism of each other's work. Significantly, it was when the cottage roof needed to be repaired that Day-Lewis was provided with the stimulus he needed to enter the detective genre. The result was *A Question of Proof* (1935), which was the first in a series of twenty-three highly successful novels featuring the detective Nigel Strangeways, written under the pseudonym of Nicholas Blake.

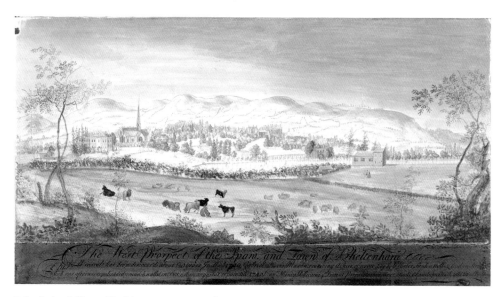

John Leland (from *The Itinerary*, 1535–1543)
To Chiltenham, a longe toune havynge a market …

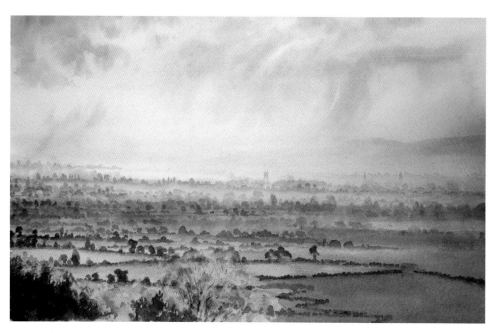

Elizabeth Raikes (from *Dorothea Beale of Cheltenham*, 1908)
The mild air and fertile soil of the great plain below the Cotswold Hills were recognised as early as the days of Edward the Confessor, when Cheltenham was called upon to furnish a large amount of bread for the royal kennels. For centuries only a little market town with a beautiful Early Gothic church on the banks of an insignificant stream, it crept out of obscurity in the pages of Ogilby who … described it as inhabited by people 'much given to plant tobacco, though they are suppressed by authority'. [...] Distinguished visitors followed … among whom, as a boy, came Byron, to wander, according to a Continental biographer, 'on the seashore at Cheltenham!'

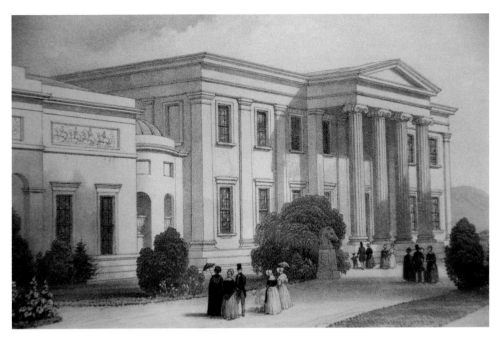

George Bernard Shaw (from *Village Wooing*, 1934)

A. Tell me: do you ever read?

Z. I used to read travels and guide books. We used to stock the Marco Polo series. I was mad about travelling. I had daydreams about the glory that was Greece, the grandeur that was Rome, and all that flapdoodle.

A. Flapdoodle!

Z. Well, I suppose I shouldnt call it that; but it ended in my going to Rome and Athens. They were all right; but the old parts were half knocked down; and I couldnt see any glory or grandeur different to Cheltenham.

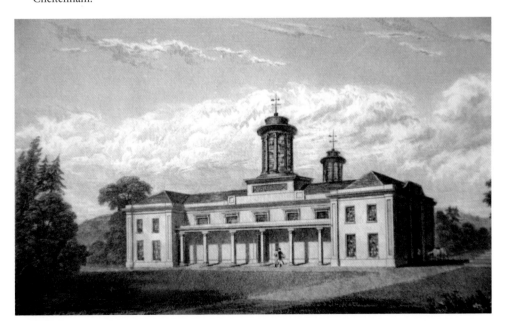

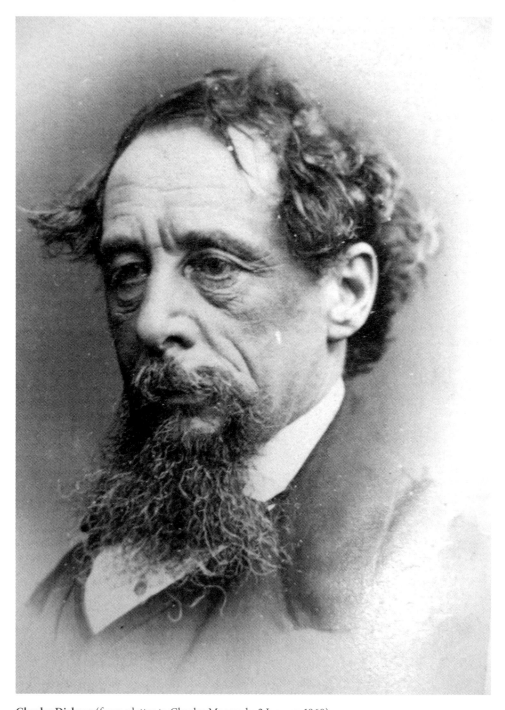

Charles Dickens (from a letter to Charles Macready, 2 January 1860)
It happened that I read at Cheltenham a couple of months ago, and that I have rarely seen a place that so attracted my fancy. I had never seen it before. Also I believe the character of its people to have greatly changed for the better. All sorts of long-visaged prophets had told me that they were dull, stolid, slow, and I don't know what more that is disagreeable. I found them exactly the reverse in all respects.

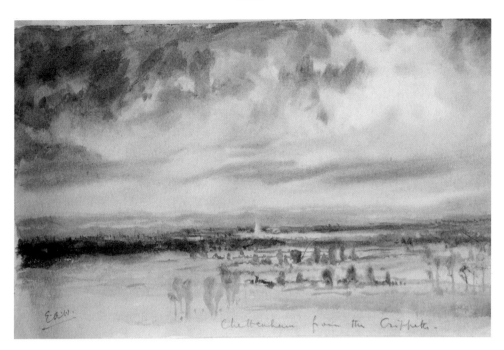

Cheltenham from the Crippetts.

Thomas Hardy (from *The Woodlanders*, 1887)
'Shall I tell you all about Bath or Cheltenham, or places on the Continent that I visited last summer?'

E. M. Forster (from *Howard's End*, 1910)
'I'll live anywhere except Bournemouth, Torquay, and Cheltenham.'

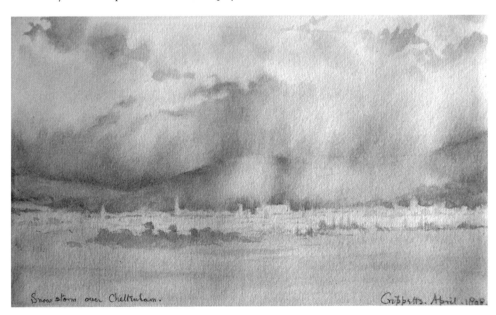

Snow storm over Cheltenham. Crippetts. April 1808.

Gustav Holst (from a letter to Isobel Holst, 1927)
The sirocco is blowing, Vesuvius is covered with clouds and the weather is muggy and damp and enervating like Cheltenham at its worst.

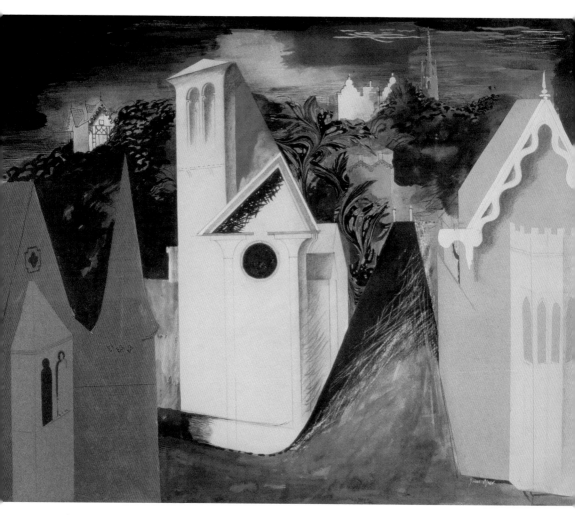

John Betjeman (from *English Cities and Small Towns*, 1943)

Cheltenham, Gloucestershire, is ... a stuccoed town in the Regency manner, with lime and chestnut shaded pavements, sunny squares, classic terraces with delicate ironwork on verandahs and basement railings, single villas, now Swiss, now Gothic, now classic, and crescents and avenues, all in cheerful yellow stucco or golden Cotswold stone, shaded by trees and lightened with flowering shrubs. Papworth and Jearrard and Underwood were the chief architects of Cheltenham in the beginning of the last century. Here army and professional people retire to drink the chalybeate waters and frequent the circulating libraries.

The Georgian Group (from *Report on Cheltenham*, 1944)

A town is more than a collection of streets and buildings. It is a composite work of art, good or bad, to the making of which many generations of men have made their contribution. Often, of course, the results are confused, mean or ugly. But a few towns have had the good fortune to be built with unity of purpose and at a time when contemporary taste was at a high level. Such towns have the rare quality of 'urbanity' – of good manners – raised sometimes to such a standard of excellence that the town becomes architecturally speaking a national possession and its residents the holders of a great responsibility. Cheltenham is one of these towns.

George Beaton (from *Jack Robinson: a Picaresque Novel*, 1933)
As I sat there looking down at the bubbles in my cup, the kitchen gardens of Cheltenham rose into my mind, the tall elms planted in black earth, the slender lines of beans and shallots and portly rows of sprouts and cabbages. In the corner by the potting-shed stood a heap of weeds that smoked like a volcano, near by a storm-wrecked grove of Jerusalem artichokes – while lower down, among the creeping ivy and dead leaves of the hedge, the first wild seedlings were already pushing up their delicate stems.

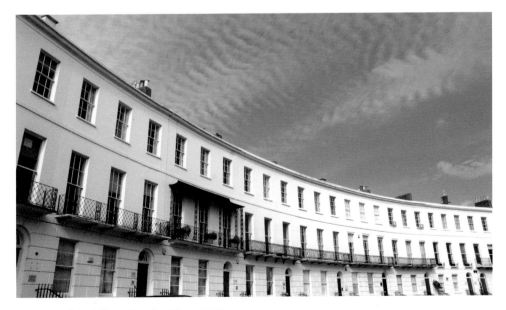

Robert Goddard (from *Hand in Glove*, 1992)
To Charlotte, Cheltenham seemed like a less hilly version of Tunbridge Wells. There was the same abundance of Regency architecture, the same bustling but well-ordered gentility. She arrived in the heat of early afternoon and spent an uncomfortable half hour locating Park Place, where Lulu lived among the many similar tree-lined residential roads south of the centre.

James Elroy Flecker ('November Eves' from *The Old Ships*, 1915)
November Evenings! Damp and still / They used to cloak Leckhampton hill, / And lie down close on the grey plain, / And dim the dripping window-pane, / And send queer winds like Harlequins / That seized our elms for violins / And struck a note so sharp and low / Even a child could feel the woe. / Now fire chased shadow round the room; / Tables and chairs grew vast in gloom: / We crept about like mice, while Nurse / Sat mending, solemn as a hearse, / And even our unlearned eyes / Half closed with choking memories. / Is it the mist or the dead leaves, / Or the dead men – November eves?

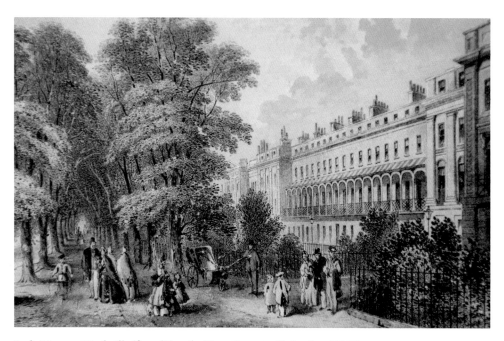

Lady Margaret Sackville (from 'How the Trees Came to Cheltenham', 1947)
You'll find no place, search all the world who may, / So countrified, so urban and so gay, / Or where in perfect union, wild yet free, / Live on an equal footing street and tree.

Elizabeth Gillard (from *The Tale of a Cheltenham Lady*, 2009)

Our home was in Suffolk Square – a gracious and imposing square of baroque Victorian eighteenth and early nineteenth-century terraces and houses, resplendent with their stucco facades. Vividly coloured magnolias and honeysuckles snaked up to intricately carved balconies. An overall air of impeccable breeding and an aura of gentility. This elegant part of Cheltenham had become a desirable area for members of the comfortable upper echelons of society, such as retired army officers, wealthy aristocrats, or, occasionally, less wealthy aristocrats who had fallen on hard times.

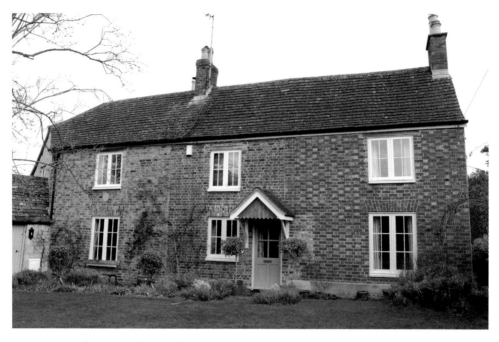

C. Day-Lewis (from *Buried Day*, 1960)

All went well enough at Box Cottage for about three years. Then our stone-tiled roof developed a leak; this circumstance had two unforeseen results – it nearly got me sacked from the College staff, and then it enabled me to give up teaching. We were told it would cost £100 to repair the roof properly. I could see no way of acquiring this sum honestly, until it occurred to me that I had read a vast number of detective novels and might be able to write one myself. I did so. *A Question of Proof* was accepted by Collins and published early in 1935.

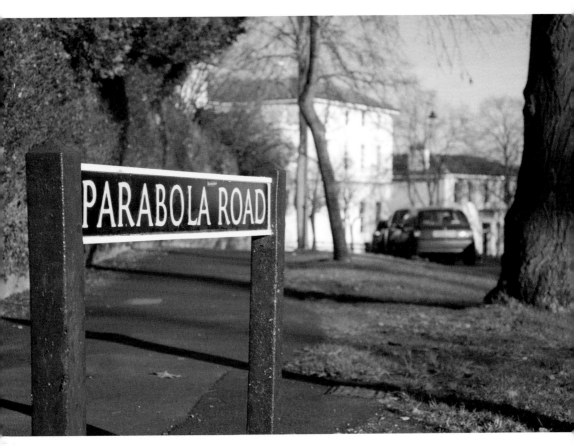

M. J. Trow (from *Lestrade and the Guardian Angel*, 1999)
Cheltenham in the grip of winter was a wonderland. The fountains were frozen and the watery sun dazzled and sparkled on the dripping cascades. Mile after mile of mellow, Cotswold villas spoke of opulence beyond the imagination of the three Yard men. The odd dark faces among the genteel throng also spoke of India. Cheltenham was wall to wall with Pukka Sahibs and Nabobs who had retired here for the saline and chalybeate springs and many had brought their ayahs and syces back with them. [...] They crossed Montpelier Walk, around the Rotunda and on to Queen's Parade. A sharp right brought them into Parabola Road and they rang the bell outside the door of Number Thirteen. There was no reply, but as Lestrade glanced upward at the tracery of wrought iron that graced the balcony, he saw the nets in the window above shiver aside. With that there was a sliding of bolts and a rattling of keys and a hideous old woman stood there.

M. J. Trow (from *Lestrade and the Gift of the Prince*, 2000)
'Would I be right in assuming you're itching to be back in Cheltenham, sir?' Lestrade sensed a certain transience about this man.
 'Cheltenham?' Maclean blinked. 'Have you been there?'
 Lestrade nodded, recalling his murky past. A distinctly strange family who lived in Parabola Road. All in all, not the happiest of memories.
 'Well, there you are', Maclean shrugged. 'There's only one thing worse than Cheltenham, Lestrade, and that's an evening in Galashiels. No, I itch, as you put it, to be off to Tangier.'

Sapper [Herman Cyril McNeile] (from *Bulldog Drummond*, 1920)
As soon as Darrell had gone, Drummond again rang the bell for his servant.

‘This afternoon, James, you and Mrs Denny will leave here and go to Paddington. Go out by the front door, and should you find yourselves being followed – as you probably will be – consume a jujube and keep your heads. Having arrived at the booking office – take a ticket to Cheltenham, say good-bye to Mrs Denny in an impassioned tone, and exhort her not to miss the next train to that delectable inland resort. [...] Then, James, you will board the train for Cheltenham and go there. You will remain there for two days, during which period you must remember that you’re a married man – even if you do go to the movies.’

Adrian Mitchell (from *Naked in Cheltenham or the Music will Never Stop*, 1978)
'Meet the Caryatids'
The first Caryatid I met / Was holding up a frieze of leaves / Over Cheltenham Fine Art and Sketchley
We Dry Cleanest / Her lower lip was full and maybe even bruised / Her shoulders were grimy, something
had dented her nose / The second Caryatid I met was cleaner and sadder She stood guard above a
cardboard box / Bright with RIPE BANANAS / The third Caryatid seemed to be whistling, / The next
was glum, / The next was vacant, / The next was dominant, / The next was timid, / The next was smooth.
/ I would like to come back to the Festival of Literature / And give each Caryatid a name of her own /
After all even the Seven Dwarfs had names.

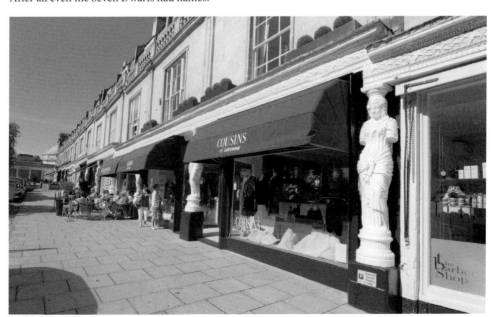

Washington Irving (from *Excursion from Edinburgh to Dublin*, 1820)

I remember one morning at Cheltenham last autumn, returning with a companion from a walk to the Spas, and crossing by a fairy little bridge, a gurgling sporting rivulet scarcely two yards over, the beauty of which I had several times previously remarked, I inquired in a tone of unaffected doubt, if there were any name to that pretty brook? '*Brook!*' replied the other, with a countenance of mingled surprise and concern, 'it is the *river Chelt*.' I looked hastily again, and almost expected to see the indignant spirit of the stream, bending in misty semblance on the view, prepared to assert its honour, and avenge the affront.

Graham Greene (from *Loser Takes All*, 1954)
I said, 'When were you last in Cheltenham … ?'
 The devil was about us that night. Whatever I said had been written into my part. She replied promptly, 'Dear Cheltenham … how did you discover … ?'
 'Well, you know, a handsome woman catches one's eye.'
 'You live there too?'
 'One of those little houses off Queen's Parade.'
 'We must be near neighbours', and to emphasize our nearness I could feel her massive mauve flank move ever so slightly against me.

Penelope Lively (from 'Nice People', in *Pack of Cards*, 1986)
In any case, he thought, turning to go into the house, it is all quite ridiculous, they are making an absurd fuss about nothing, what on earth do they think can happen to the girl in Cheltenham, of all places? It's not exactly a den of iniquity.

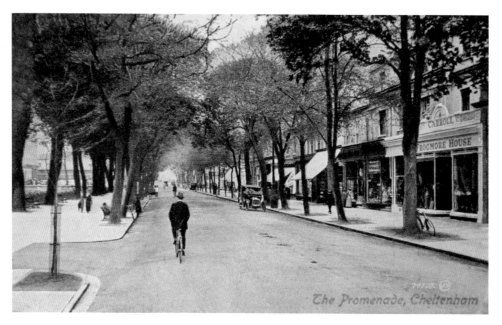

Virginia Woolf (from her diary, 19 February 1923)
She amused me by saying that the streets of Cheltenham are notoriously unsafe. Foot passengers are perpetually killed by bicyclists. It is the rarest thing to motor through without being asked to take a corpse to the doctors.

Adrian Mitchell (from *Naked in Cheltenham or the Music will Never Stop*, 1978)
Frances says of Cheltenham: 'It's the only place I've ever had a parking fine. I also avoid going there because you tend to spend money there.' Later I hear from a friend, 'The nearest thing to intellectual stimulation is Cheltenham's one-way traffic system.'

2

PEOPLE

A small selection of the extraordinary range of individuals associated with Cheltenham is found in the clerihews by Peter Wyton, former poet laureate for Gloucestershire. Yet even this 'compendium' omits Edward Wilson, Cheltenham's Antarctic hero, whose fine character was eloquently captured in one of Captain Scott's last letters before he perished at the South Pole. Also absent is Josephine Butler, the remarkable feminist social reformer, who used the power of writing to campaign vigorously for women's rights, even uncovering unsavoury facts about high-class prostitution in her final years at Cheltenham. Moreover, one should include numerous poets and writers who stayed in the town. Alfred Lord Tennyson, for example, is thought to have written his epic poem *In Memoriam* while staying at the family home at 10 St James's Square. Lord Byron was another temporary resident, initially living in a 'sordid Inn' on the High Street before moving to Georgiana Cottage, on the corner of Bath Street, where he claimed that the 'sufficiently disgusting' medicinal waters had disordered his heart.

Also, any reflections on Cheltenham people cannot overlook the importance of the Revd Francis Close who, given his aversion to Catholicism, was ironically described by Tennyson as Cheltenham's 'Pope'. Close came to dominate much of Cheltenham's life through the power of his sermons and various causes he espoused. It was Close's opposition to postal deliveries on Sundays which brought him into direct conflict with Anthony Trollope who, as post office surveyor, was attempting to introduce these to the town. Although Close won the day in the end, Trollope never forgot his bitter battle fought against the preacher and later, in *Miss Mackenzie*, portrayed him as Mr Stumfold who 'was always fighting the devil by opposing those pursuits which are the life and mainstay of such places as Little-bath'. Inevitably, this included the 'Stumfoldian edict ... ordaining that no Stumfoldian in Littlebath should be allowed to receive a letter on Sundays'.

Lastly, Cheltenham has also provided inspiration for the creation of fictional characters. P. G. Wodehouse, for example, discovered his 'Jeeves' while watching Gloucestershire play Warwickshire at the College cricket ground (see Chapter 5), and the Revd Charles Dodgson, better known as Lewis Carroll, met his Alice here, drawing on this experience to develop a second book of *Through the Looking Glass* adventures. It was in 1863 that Dodgson visited the Revd and Mrs Henry Liddell at Hetton Lawn, Cudnall Street, in Charlton Kings. Alice Liddell, who was holidaying with her sisters at their grandparents' house at the time, originally inspired Carroll to write *Alice's Adventures in Wonderland* (1865). During this visit Carroll also first saw a famous ornate mirror at Hetton Lawn which, it is believed, later inspired him to write the sequel, *Through the Looking Glass* (1871). It is also thought that the visit provided further inspiration for the book – when Dodgson took the three Liddell girls for a walk on Leckhampton Hill, they looked down on the Severn Vale countryside which appeared, as described in Wonderland, 'marked out just like a giant chess board'. Also accompanying them on the walk was Miss Prickett, the governess for the Liddell children who, according to Carroll, was the prototype for the Red Queen, 'the concentrated essence of all governesses'!

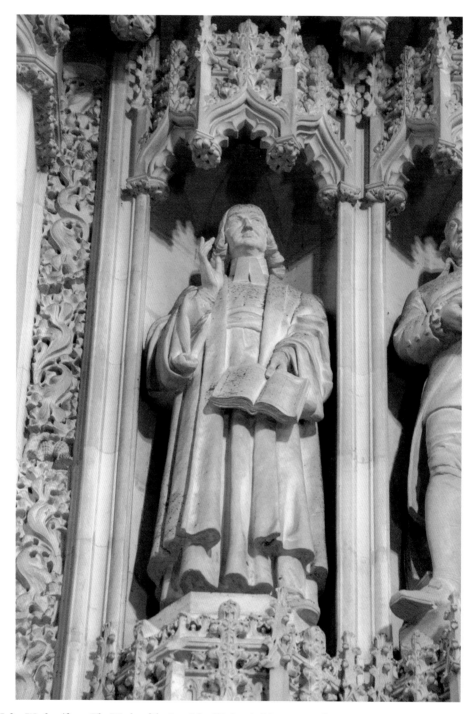

John Wesley (from *The Works of the Rev. John Wesley, A. M.*, 1771–1774)
I called at Gloucester, designing only to speak with a friend; but finding an house full of people, I would not disappoint their expectation, but stayed and preached on the form and the power of godliness. This made me somewhat later than I intended at Cheltenham, where I preached on, 'By grace are ye saved through faith', to a company who seemed to understand just as much of the matter, as if I had been talking Greek.

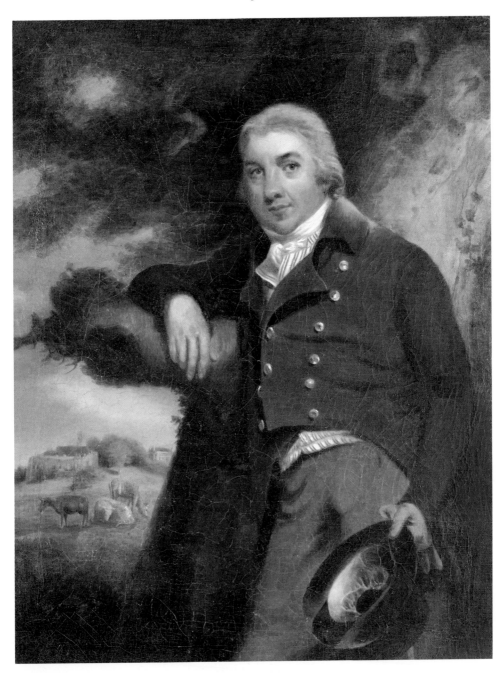

Christopher Anstey (from 'Ode to Edward Jenner', 1803)
[Anstey's Latin Ode to Jenner was translated by John Ring in 1804.]
Oh! blest by Phoebus, at thy natal hour! / The happy presage of thy healing pow'r! / 'Tis thine to study nature's hidden laws, / Trace all her wonders to their secret cause; / Prevent disease with thy Paeonian art, / Encounter Death, and blunt his fatal dart. / While thus I rove through Chelta's flow'ry plain, / And some faint embers of my youth remain, / Shall not the muse her tuneful accents raise, / And wake her slumb'ring lyre to sing thy praise?

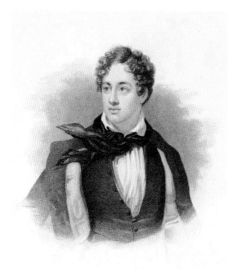

Lord Byron (from a letter to Lord Holland, 10 September 1812)

... My best respects to Lady H.: – her departure, with that of my other friends, was a sad event for me, now reduced to a state of the most cynical solitude. 'By the waters of Cheltenham I sat down and *drank*, when I remembered thee, oh Georgiana Cottage! As for our *harps*, we hanged them up upon the willows that grew thereby. Then they said, Sing us a song of Drury Lane,' &c.; – but I am dumb and dreary as the Israelites. The waters have disordered me to my heart's content – you *were* right, as you always are. Believe me ever your obliged and affectionate servant, Byron.

Lord Byron (from a letter to William Bankes, 29 September 1812)

I have been here for some time drinking the waters, simply because there are waters to drink, and they are very medicinal, and sufficiently disgusting.

Elizabeth Barrett Browning (from a letter to Mr Westwood, 22 May 1845)

[Tennyson] likes London, I hear, and hates Cheltenham, where he resides with his family, and he smokes pipe after pipe, and does not mean to write any more poems. Are we to sing a requiem?

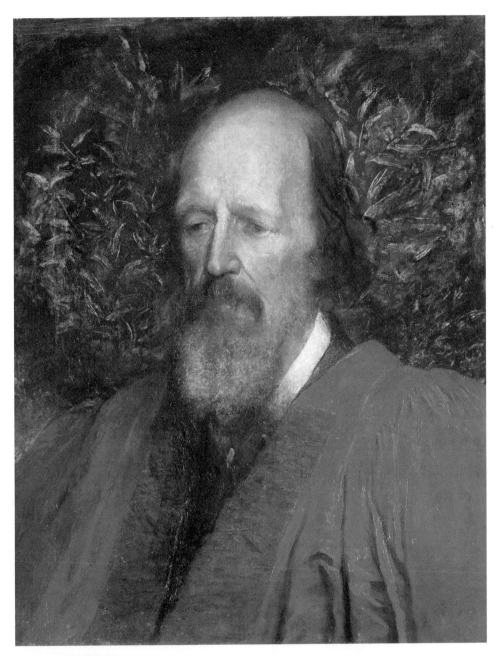

Ralph Waldo Emerson (from *Journal*, 1848)
Yet Tennyson would not say a word, but sat with his pipe, silent, and at last said, 'I am going to Cheltenham; I have had a glut of men.'

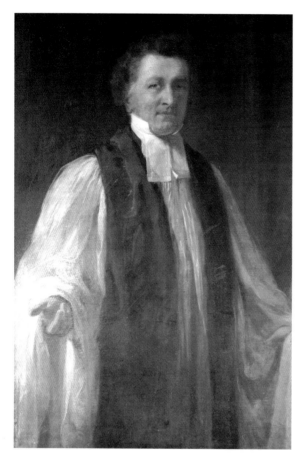

Alfred Tennyson (from a letter to a friend, 1845)
Here is a handsome town of 35,000 inhabitants, a polka-parson-worshipping place, of which the Revd Francis Close is Pope, besides pumps and pump-rooms, chalybeates, quadrilles, and one of the prettiest counties of Britain.

Anthony Trollope (from *Miss Mackenzie*, 1865)

[Trollope satirises the Revd Francis Close in the portrayal of Mr Stumfold.]

Now Mr Stumfold was a shining light at Littlebath, the man of men, if he was not something more than mere man, in the eyes of the devout inhabitants of that town. Miss Mackenzie had never heard of Mr Stumfold till her clergyman in London had mentioned his name, and even now had no idea that he was remarkable for any special views in Church matters. Such special views of her own she had none. But Mr Stumfold at Littlebath had very special views, and was very specially known for them. His friends said that he was evangelical, and his enemies said that he was Low Church. He himself was wont to laugh at these names – for he was a man who could laugh – and to declare that his only ambition was to fight the devil under whatever name he might be allowed to carry on that battle. And he was always fighting the devil by opposing those pursuits which are the life and mainstay of such places as Littlebath. His chief enemies were card-playing and dancing as regarded the weaker sex, and hunting and horse-racing – to which, indeed, might be added everything under the name of sport – as regarded the stronger. Sunday comforts were also enemies which he hated with a vigorous hatred, unless three full services a day, with sundry intermediate religious readings and exercitations of the spirit, may be called Sunday comforts. But not on this account should it be supposed that Mr Stumfold was a dreary, dark, sardonic man. Such was by no means the case. He could laugh loud. He could be very jovial at dinner parties. He could make his little jokes about little pet wickednesses. A glass of wine, in season, he never refused. Picnics he allowed, and the flirtation accompanying them. He himself was driven about behind a pair of horses, and his daughters were horsewomen. His sons, if the world spoke truth, were Nimrods; but that was in another county, away from the Tantivy hills, and Mr Stumfold knew nothing of it. In Littlebath Mr Stumfold reigned over his own set as a tyrant, but to those who obeyed him he was never austere in his tyranny.

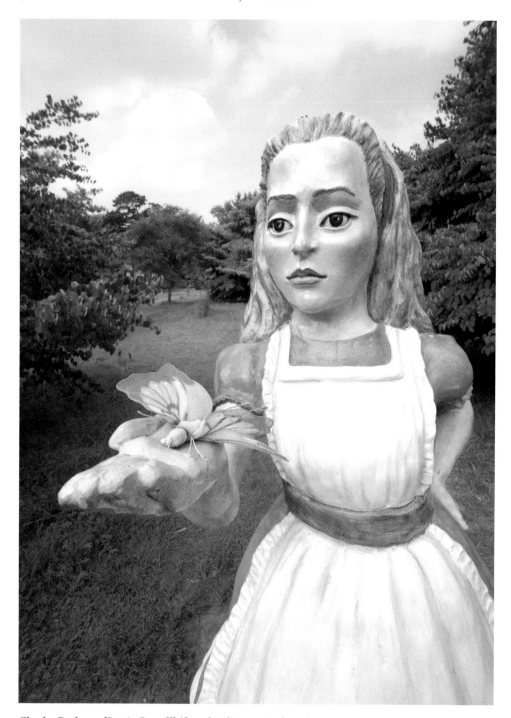

Charles Dodgson [Lewis Carroll] (from his diary, 4 April 1863)
Reached Cheltenham by 11.30 a.m. I found Alice waiting with Miss Prickett [her governess] at the station, and walked with them to Charlton Kings ... In the afternoon we went a large party in the carriage up to Birdlip, where Ina, Alice and Miss Prickett got out, and walked back with me over Leckhampton Hill. Except for the high wind, the day could hardly have been better for the view.

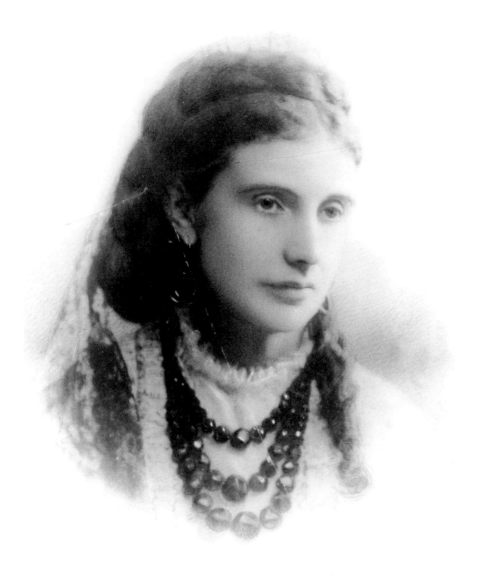

Josephine Butler (from a letter to Fanny Forsaith, 13 December 1902)
I watched the gay, graceful slave of vice from my window as she left, & my heart bled for her.
I was too ill then to go to her, but we followed her up, & found her afterwards in a house of ill
fame, patronised by *gentlemen*, and as fenced & protected by someone, perhaps some of [the]
municipality, as much as a 'maison tolerée' abroad. Such an atmosphere of French vice, & this is
not the *only house* here [in Cheltenham] of the kind.

Jerome K. Jerome (from *The Angel and the Author*, 1904)
The American colonel is still to be met with here and there by the curious traveller, but compared with the retired British general he is an extinct species. In Cheltenham and Brighton and other favoured towns there are streets of nothing but retired British generals – squares of retired British generals – whole squares of retired British generals – whole crescents of British generals.

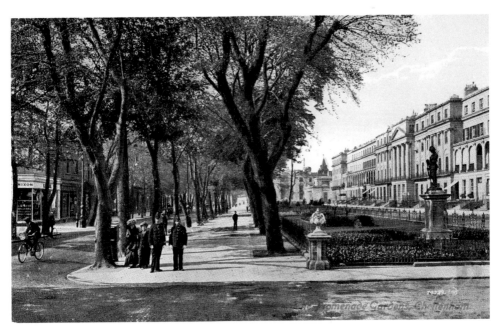

W. H. Davies (from *Autobiography of a Super-Tramp*, 1907)

[The officer] began to read, often raising his eyes to scrutinise my person. 'Yes,' he said, at last, 'no doubt you are the man I want, for you answer his description.' 'I suppose,' was my answer, 'it is a case of arrest?' 'It is,' he said, 'and you must accompany me to the station.' On my way to that place he asked many a question of what I had done with my overcoat, and as to the whereabouts of my wife. It had been several years since I had owned the former, and the latter I had never possessed; but this man could not be convinced of either. 'Which way have you come?' he asked. To which I mentioned one or two shires. At this he pricked up his ears, and asked if I had been in a certain town in one of those shires, which I had, and saw no reason to say otherwise. Unfortunately this was the town where the guilty man had operated. The detective was certainly not very smart when he took this confession as evidence of guilt, for the guilty man would have mentioned that particular town as one of the last places to visit. I certainly answered to the description of the man wanted, with the exception of not having a blotchy face, which had been characteristic of the guilty man. [...] Of course, I was discharged in an hour, and returned to the lodging house for the night. The following day I happened to be in Dorking, and was walking through that town, when I heard quick steps behind me, and a voice cry 'Halt: I want you.' Turning my head I saw it was a police officer. This man at once took possession of me, saying that he fortunately had been looking through the police station window, when he saw me passing, and that I answered to the description of a man wanted – 'for that affair at Cheltenham,' I added. 'Ha,' he said, his face lighting with pleasure, 'how well you know.' We returned quietly to the police station, and when I confronted his superior officer, I asked that person if I was to be arrested in every town through which I passed; telling my experience the night before at Guildford. After one or two questions, and a careful reading of the description paper, also an examination of my pedlar's certificate, he told me I was at liberty to go my way.

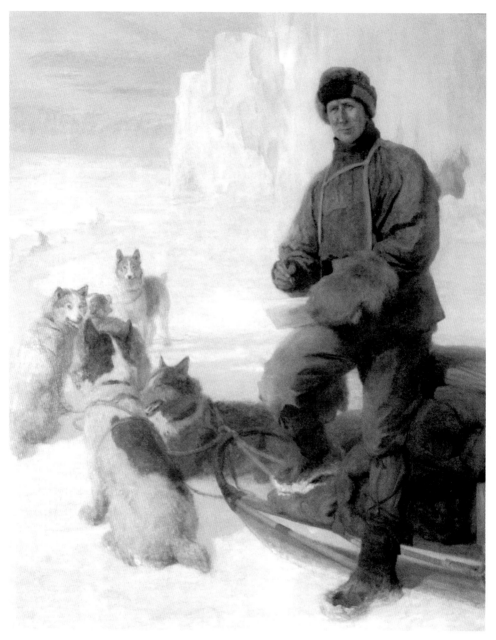

Robert Falcon Scott (from a letter to Oriana Wilson, March 1912)
[The last seventeen words are included on the Wilson statue on The Promenade.]
His eyes have a comfortable blue look of hope and his mind is peaceful with the satisfaction of his faith in regarding himself as part of the great scheme of the Almighty, I can do no more to comfort you than to tell you that he died as he lived, a brave, true man – the best of comrades and staunchest of friends.

Lillah McCarthy (from *Myself and My Friends: a Life on the Stage*, 1933)
The impressions made on me by these childhood days in Cheltenham are as vivid now as they were when they first printed themselves upon my memory. The well-planned town, with its leisured gentlefolk ... I see it now, as I saw it then, as a perfect setting for a life of well-bred retirement, a place where people grown old in the service of their country find peace and modest comfort. I see the retired majors going to the club. I hear the snore of their afternoon siestas.

Peter Wyton ('Cheltenham Clerihews', produced as part of a project for the Cheltenham Art Gallery & Museum Education and Outreach Service, 2001)

Dorothea Beale, a woman of knowledge, / Was Principal of the Ladies' College. / If she'd survived to witness the mini-skirt, / She'd have been curt.

George Dowty, / Was anything but gouty. / With considerable agility, / He made aircraft parts for the military.

George the Third stayed at Bayshill House, / Along with his spouse / And, in all probability, some sons & daughters, / Whilst taking the waters.

Arthur Harris, who organised many a wartime air raid, / Was born at 3, Queens parade. / He was nicknamed Bomber, / (without the comma).

The Baron de Ferrieres / Never drank Perrier, / Or kept a pet crow, / As far as I know.

The Reverend Francis Close / Was caustically verbose / About alcohol, tobacco, theatre and racing. He probably thought cricket / Was wicked.

Gustav Holst was asthmatic, / Which was problematic, / But he wrote the Planet Suite, / So he didn't have to busk in the street.

Edward Jenner / Gave men or / Women, with considerable charm, / A shot in the arm.

Born in Cambray Place. / Followed W. G. Grace / As captain of Glos. / Gilbert Jessop, of course.

Brian Jones / Of the Rolling Stones / Left here / For a pop career.

They should have put a cordon / Around actress Dorothy Jordan / To keep off / William the Fourth.

Celebrated Shakespearian. / Wish he was here again. / William Macready. / Yes, indeedy.

3

THE FASHIONABLE SPA

In its heyday as a spa between 1790 and the 1830s, Cheltenham was so popular as a fashionable resort that it even rivalled Bath and London. Indeed, following King George III's visit in 1788, to quote a London newspaper, all the fashions became 'completely Cheltenhamised'. The king's visit was described first-hand both by the milkmaid poet Ann Yearsley and the diarist and novelist Fanny Burney who accompanied the royal party as lady-in-waiting to Queen Charlotte. Through its centre of gravity as one of the most favoured of watering-places, the town also attracted famous writers, including Elizabeth Barrett Browning, Lord Byron, Sir Walter Scott, Ireland's national poet Thomas Moore, and Jane Austen, who visited for three weeks and was aggrieved to hear that her sister was charged three guineas a week for her lodging and accused the landlady of charging for 'the *name* of the High Street'. Some, like Johanna Schopenhauer, mother of the renowned German philosopher, William Cobbett and Samuel Johnson, were not impressed by the idleness of the place and the predominance of decadent lifestyles. It was also during this period that Prince Hoare, the dramatist and artist, spent the season at Cheltenham and wrote *Three and the Deuce* (1795), a play based on the Spanish comedy of errors *Los Tres Mellizos*. First performed at London's Haymarket, the drama concerned three brothers, Pertinax 'the modest man', Peregrine 'the rattlebrain' and Percival 'the simple soul', who find themselves in the same Cheltenham inn, where they play out comic adventures including looking for pretty girls who frequent the wells.

As a place of 'fashion and folly' it was inevitable that Cheltenham would become a target for gentle satire. Robert Smith Surtees was one of the first to satirise fashionable spa towns in his series of comic novels featuring John Jorrocks, a self-made Cockney grocer with a penchant for fox hunting. Cheltenham is mentioned by name in Surtees' first work of fiction, *Jorrocks' Jaunts and Jollities* (1838), and, five years later, is used as a point of reference for Handley Cross, the development of which – following the discovery of its medicinal springs – bears remarkably close similarities to Cheltenham at the beginning of the nineteenth century.

On the other hand, Charles Molloy Westmacott, the journalist and blackmailer who published under the pseudonym Bernard Blackmantle, and William Thackeray, took a more acerbic approach when writing about Cheltenham. In *Vanity Fair*, for example, Thackeray described it as a place 'wherever trumps and frumps were found together; wherever scandal was cackled', while in *The Book of Snobs* he included characters such as Lady Fanny Famish who, we are told, 'resides at Cheltenham, and is of a serious turn'. It was characters such as these that helped Thackeray to popularise the meaning of the word 'snob' through the pages of *Punch*. Lastly, Anthony Trollope, although not generally known for satirical writing, also launched a severe attack on Cheltenham. This was often through the thinly veiled disguise of Littlebath and arose partly through coming into conflict with the Revd Francis Close (see Chapter 2), but also from his early experience in childhood when he witnessed how a Cheltenham landlord had unfairly blighted his father's efforts to become a gentleman farmer.

John Byng (from *Torrington Diaries*, 1781–1784)

27 June [1781]

I quit thee with pleasure, and hope never more to revisit thee! I believe I may aver and be agreed with, that Cheltenham is the dullest of public places; the look of the place is sombre, the lodgings dear and pitiful, and no inns or stabling fit for the reception of gentlemen or their horses.

28 June [1781]

… I attended a troupe of Morrice dancers headed by a buffoon; but to me their mummery appear'd tedious and as little enjoyed by the performers as by the spectators; the genius of the nation does not take this turn.

27 June [1784]

I attended at the pump room this morning, but neither drank the water, nor embark'd in society, as it wou'd only be a needless trouble.

Ann Yearsley (from 'To The King On His Majesty's Arrival at Cheltenham 1788')
Then pause Thou Pow'r of Song! O'er Chelt'nham bend! / Check thy hot Coursers, nor in haste descend, / To oceans bosom! - till with daring flight / I from thy Chariot snatch some rays of Light, / I feel thy flame! Thy strong effulgence Mine! /And George adds lustre, to thy beams divine.

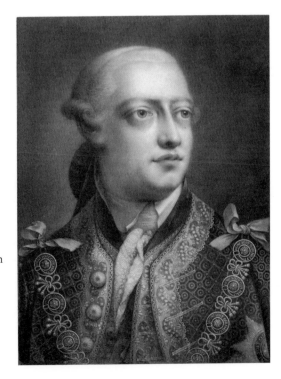

Flora Fraser (from *Princesses: The Six Daughters of George III*, 2004)
'Never did schoolboys enjoy their holidays equal to what we have done,' wrote the Queen after the July 1788 visit to Cheltenham. 'The King went there without any guards', which pleased the local people. 'At various times have they thrown out that he was better guarded without troops walking among his subjects whose hearts were ready to defend him.'

Fanny Burney (from *Diary and Letters of Madame D'Arblay*, 1842–1846)
The King declared the Cheltenham waters were admirable friends to the constitution, by bringing disorders out of the habit. [...] Saturday, August 16th – We left Cheltenham early this morning. Major Price breakfasted with us, and was so melancholy at the King's departure he could hardly speak a word. All Cheltenham was drawn out into the High-street, the gentles on one side and the commons on the other, and a band, and 'God save the King,' playing and singing.

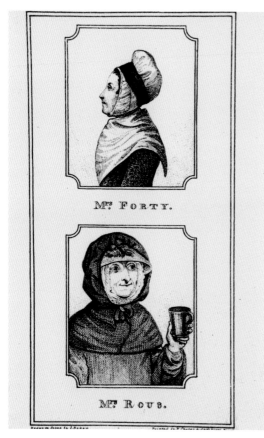

Barbara Cartland (From *The Mysterious Maid-Servant*, 1977)
'Mrs Forty is a well-known pumper who serves the King and Queen and the Royal Family when they come [to Cheltenham] and whose portrait was painted at His Majesty's command.'

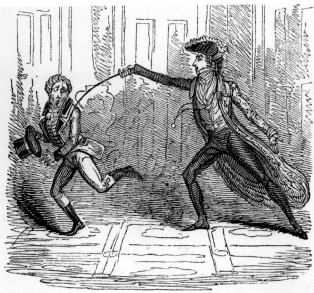

Prince Hoare (from *The Three and the Deuce; or, Which is Which?*, 1795)
Peregrine. [Fencing at Humphrey.] And this is for you! Parry – carte – segond – tierce! Ha! ha!
Humphrey. Lord, sir! What are you at?
Peregrine. At – at your fifth button hole!

R. *Cruikshank, Del.* G. *W. Bonner, Sc.*

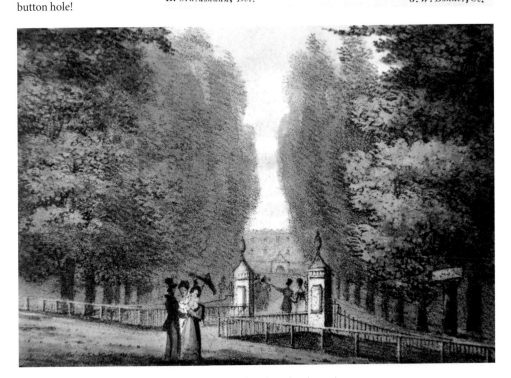

Johanna Schopenhauer (from *Travels in England and Scotland*, 1803)
Cheltenham consists of a single street … On this main street there are elegant buildings, glittering shops, lending libraries and cafés. Here, in the morning, the *beau monde* strolls slowly by but also, as it seemed to us, with much boredom. The ladies crawl about in twos and threes from one shop to the next, whilst the gentlemen try in their own way to while away their precious time by riding, drinking and reading the newspapers.

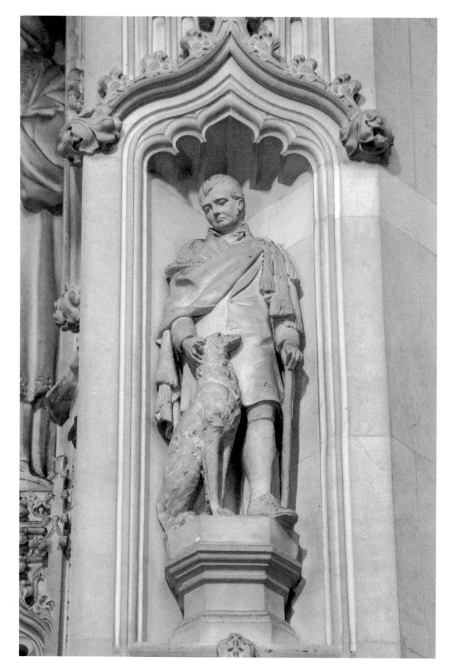

Sir Walter Scott (from a letter, 15 April 1812)
I have had as many remedies sent me for cramp and jaundice as would set up a quack doctor
... besides all sort of recommendations to go to Cheltenham, to Harrowgate, to Jericho for
aught I know. Now if there is one thing I detest more than another, it is a watering-place.

Sir Walter Scott (from *St. Ronan's Well*, 1824)
'The doctors insist I must use Cheltenham, or some substitute, for the bile – though, d—n
them, I believe it's only to hide their own ignorance.'

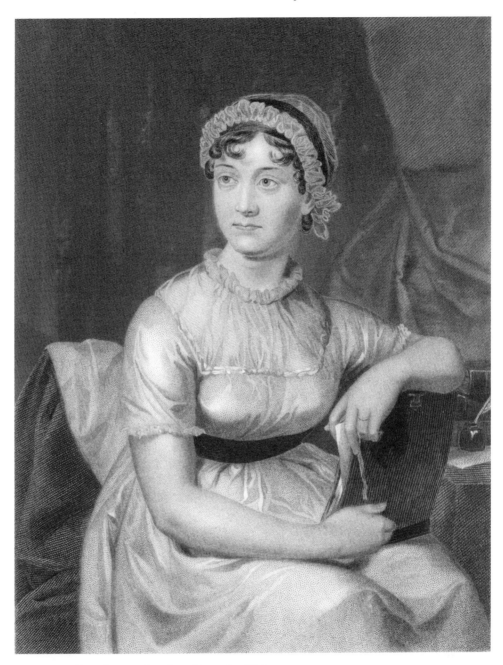

Jane Austen (from letters to her sister Cassandra, 1816)
4 September
But how very much Cheltenham is to be preferred in May!
9 September
I am very glad you find so much to be satisfied with at Cheltenham. While the Waters agree, everything else is trifling. […] I hope Mary will change her Lodgings at the fortnight's end; I am sure, if you looked about well, you would find others in some odd corner, to suit you better. Mrs Potter charges for the <u>name</u> of the High St …

Elizabeth Barrett Browning (from 'Lines Extempore on Taking My Last Farewell of the Statue of Hygeia at Cheltenham', 1818)
Hygeia queen and daughter / Of Cheltenham's boasted water / There art thou condemned to dwell / Here am not I, so queen farewell!

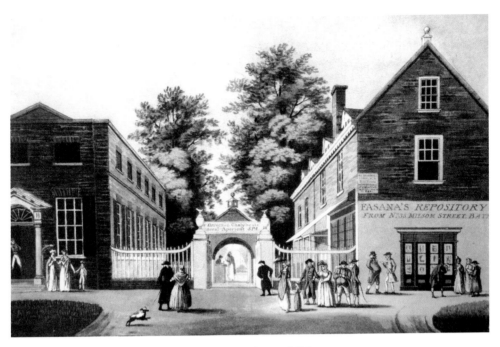

David Garrick (from a letter to Francis Hayman, 18 August 1746)
I came to this Place last Thursday, & a damn'd dull Place it is, ... I have drank the Waters and they agree very well with Me; but I have unfortunately got a Boil under the Wasteband of my Breeches, that greatly discomposes Me & perhaps my Wont of Relish for the Pleasures of Cheltenham may be chiefly owing to that.

William Cowper (from a letter to a friend, 1788)
I have been somewhat alarmed lately for Mr Chester, who I hear has a carbuncle on his back; a very painful, and which is worse, a dangerous distemper, especially to a man like him, not qualified by great strength of constitution to contend with it. He spent the summer at Harrowgate, as the King [did] at Cheltenham. If such be the consequences of water-drinking, let us abstain from all such perilous beverage and drink wine.

Daniel Defoe (from *A Tour Thro' the Whole Island of Great Britain*, 1762)
A very eminent Physician is of Opinion, that the Waters of Bath, Tunbridge, Cheltenham (or Scarborough, which partake of the same Qualities), and Bristol, make the general Kinds of most of the various Mineral Waters on the Globe; and that he therefore who understands these, cannot be much at a Loss to determine the Virtues and Efficacy of any new Kind.

Captain Frederick Marryat (from *The King's Own*, 1830)
Mrs Rainscourt and her daughter were equally objects of curiosity, not likely to pass unnoticed in such a place as Cheltenham, where people have nothing else to do but talk scandal, and to drink salt water as a punishment.

Winthrop Mackworth Praed (from 'My Partner', 1844)
At Cheltenham, where one drinks one's fill / Of folly and cold water, / I danced last year my first quadrille / With old Sir Geoffrey's daughter. / Her cheek with summer's rose might vie, / When summer's rose is newest; / Her eyes were blue as autumn's sky, / When autumn's sky is bluest; / And well my heart might deem her one / Of life's most precious flowers, / For half her thoughts were of its sun, / And half were of its showers.

John Betjeman (from *Bird's Eye View* [TV series looking at Britain from a helicopter], 1969)
Quality sent its sons and daughters / In search of health to inland waters / To Roman Bath or Cheltenham Spa, / Where the Chalybeate fountains are.

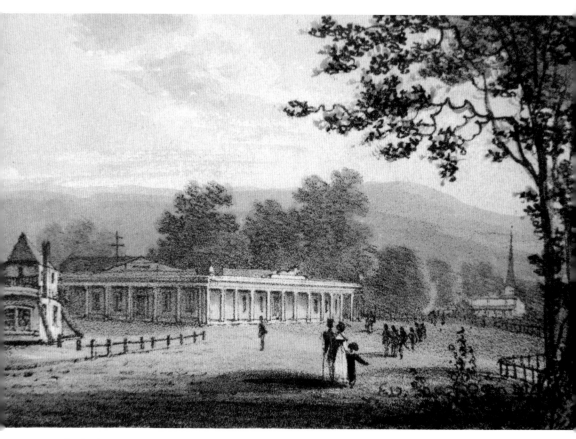

Elizabeth Barrett Browning ('On Thompson's Spas Cheltenham', 1819)

Neglected theme of lyric lore
Thompsons own pure immortal spa
Say healing springs from whence ye flow
What fount can yield ye here below
Or are your balmy streamlets driven
Pure from the bounteous hand of Heaven.
Thy Virtues salutary spring
Praise echos and the Muse shall sing.
First how by hap the owners found
Four streams emerging from the ground
First novelty, next Fashions might renowned
Their powers – another soon arose.
And number five majestic flows
And last by unknown magic tricks,
Another stream, 'twas number six
The papers say, tho' last not least
And so their readers swear 'tis best.
Some sages tell that good is given
More plenteous by the hand of Heav'n
Than evil – the dispute I rue
But now I see & know it true
Then say, oh Muse, without a name

How number six arrived at fame.
Why it was ready made – and number six
Did not require another hand to mix.
So Pallas, from the brain of Jove,
Leapt forth the fear of all above
All armed thro trembling Heav'n she strode
And stalked the image of the Father God
And so the stream was thus renowned.
What other reason can be found?
Why it was salt & horrid stuff
What more? – and was not this enough?
And would not this almost incite
A spirit from the realms of light
To taste those lucid streams, for e'en the walk
To Thompsons wells, a pleasant place to talk.
Then what bright crowds are seen – when there,
The young, the old, the plain, the fair –
"Neath Esculapius" fostering wings
All sipping the benignant springs
And music aids, with her melodious note
To force the sweet solutions down the throat.

William Henry Halpin [Peter Quince the Younger] (from *Cheltenham Mail-Bag or, Letters from Gloucestershire, c.* 1820)

Men of every class and order,
All the genera and species,
Dukes with aides-de-camp in leashes,
Marquesses in tandem traces,
Lords in couples, Counts in pairs,
Coveys of their spendthrift heirs…
Hosts of soldiers, shoals of seamen;
Droves of squires and herds of farmers,

Swarms of dandies, flocks of charmers,
Troops of half-pay light dragoons,
Stores of cockneys, heaps of spoons;
Cabinets of politicians,
Ins and outs of whole divisions;
Heaps of lawyers, surgeons, proctors,
Lots of nurses, dentists, doctors,
Hovering round as ravens do.

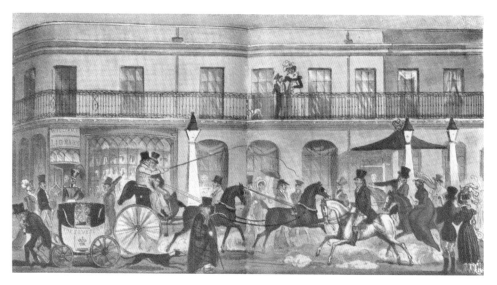

Bernard Blackmantle [C. M. Westmacott] (from *English Spy*, 1826)
From the *cercle de la basse to the cercle de la haute*, from the nadir to the zenith, 'I know ye, and have at ye all' – ye busy, buzzing, merry, amorous groups of laughter-loving, ogling, ambling, gambling Cheltenham folk.

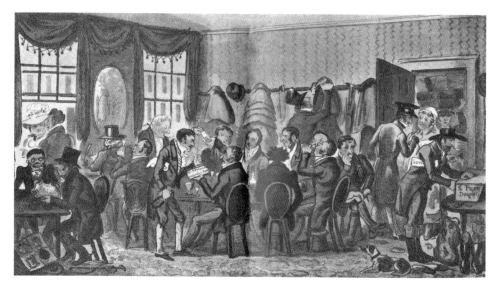

Bernard Blackmantle [C. M. Westmacott] (from *English Spy*, 1826)
If you wish to make a figure among the Chelts and be thought any thing of, you will, of course, domicile at the Plough; but if your object is a knowledge of life, social conversation, a great variety of character, and a never-failing fund of mirth and anecdote, join the gentleman travellers who congregate at the Bell or the Fleece, where you will meet with merry fellows, choice viands, good wine, excellent beds, and a pretty chambermaid into the bargain.

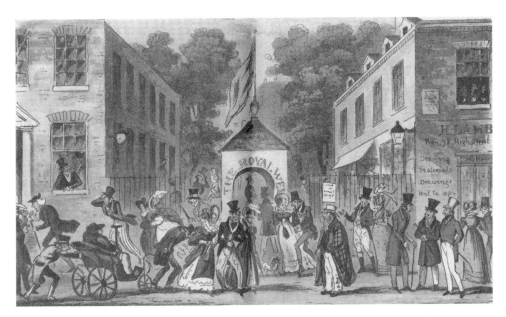

Bernard Blackmantle [C. M. Westmacott] (from *English Spy*, 1826)
'See, with what alacrity the old gentleman is moving off yonder, making as many wry faces as if he had swallowed an ounce of corrosive sublimate – and the ladies too, bless me, how their angelic smiles evaporate, and the roseate bloom of their cheeks is changed to the delicate tint of the lily, as they partake of these waters. What an admirable school for study is this! Here we can observe every transition the human countenance is capable of expressing, from a ruddy state of health and happiness, to one of extreme torture.'

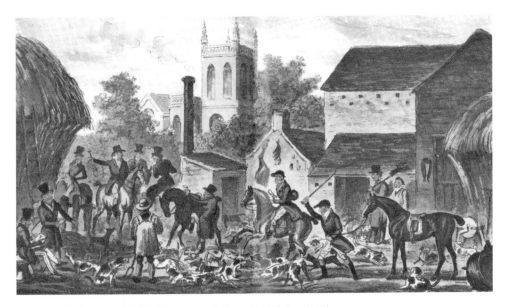

Bernard Blackmantle [C. M. Westmacott] (from *English Spy*, 1826)
Afterwards see them ... posting off to the well walks, or disturbing the peaceful dead by ambling over their graves in search of humorous epitaphs – making their way down to the Berkeley kennel in North-street.

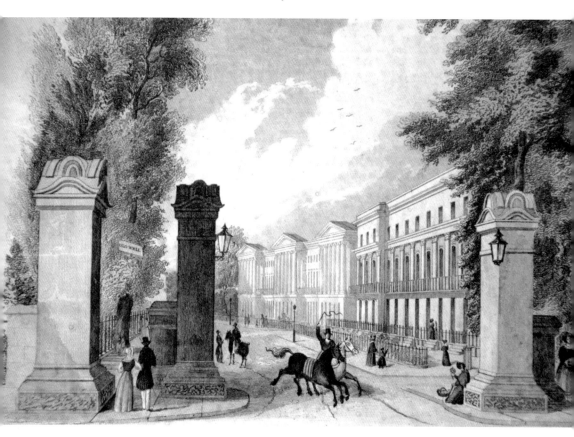

Samuel Johnson (from 'Advice to Unmarried Ladies', *Rambler*, 97, 19 February 1751)
In the summer there are in every country-town assemblies; Tunbridge, Bath, Cheltenham, Scarborough! What expense of dress and equipage is required to qualify the frequenters for such emulous appearance!

By the natural infection of example, the lowest people have places of six-penny resort, and gaming tables for pence. Thus servants are now induced to fraud and dishonesty, to support extravagance, and supply their losses.

As to the ladies who frequent those public places, they are not ashamed to show their faces wherever men dare go, nor blush to try who shall stare most impudently, or who shall laugh loudest on the public walks.

N. T. H. Bayley (from *The Aylmers, a Novel*, 1827)
Cheltenham ought beyond dispute to be acknowledged as the existing residence of the court of fashion. It is the object of the votaries of fashion to dress well, and to be *seen* well dressed. Cheltenham, therefore, offers advantages far beyond the power of all competitors.

At Cheltenham people appear on the public walks before breakfast, in fashionable costume; therefore favourable opportunities for public display are offered at the hours when, at other places, it would be disgraceful to be detected actually *visible*, without a night-cap and a morning-gown.

Edward Bulwer-Lytton (from *Pelham; or, Adventures of a Gentleman*, 1828)
The first bright morning I set off for Cheltenham. I was greatly struck with the entrance to that town: it is to these watering-places that a foreigner should be taken, in order to give him an adequate idea of the magnificent opulence, and universal luxury, of England.

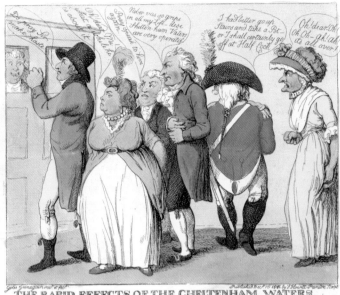

THE RAPID EFFECTS OF THE CHELTENHAM WATERS.

William Cobbett (from *Rural Rides*, 1830)

Cheltenham is a nasty, ill-looking place, half clown and half cockney. [… It] is what they call a 'watering place'; that is to say, a place to which East India plunderers, West India floggers, English tax-gorgers, together with gluttons, drunkards, and debauchees of all descriptions, female as well as male, resort, at the suggestion of silently laughing quacks, in the hope of getting rid of the bodily consequences of their manifold sins and iniquities.

Captain Frederick Marryat (from *Japhet in Search of a Father*, 1836)

'What do you say, shall we go to Cheltenham? You will find plenty of Irish girls, looking out for husbands, who will give you a warm reception.'

Robert Smith Surtees (from *Jorrocks' Jaunts and Jollities*, 1838)

Mr Jorrocks had been very poorly indeed of indigestion, as he calls it, produced by tucking in too much roast beef and plum pudding at Christmas, and prolonging the period of his festivities a little beyond the season allowed by Moore's Almanack; and having in vain applied the usual remedies prescribed on such occasions, he at length consented to try the Cheltenham waters, though altogether opposed to the element, he not having 'astonished his stomach', as he says, for the last fifteen years with a glass of water.

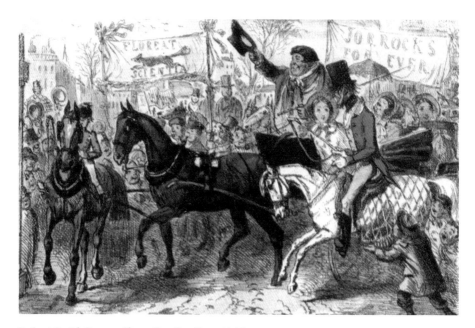

Robert Smith Surtees (from *Handley Cross*, 1843)

The Handley Cross mania spread throughout the land! Invalids in every stage of disease and suffering were attracted by Roger's name and fame. The village assumed the appearance of a town.

William Makepeace Thackeray (from *Vanity Fair*, 1847–1848)
As they passed, they met the carriage – Jos Sedley's open carriage, with its magnificent armorial bearings – that splendid conveyance in which he used to drive, about at Cheltenham, majestic and solitary, with his arms folded, and his hat cocked; or, more happy, with ladies by his side. [...] As the carriage drove off he kissed the diamond hand to the fair ladies within. He wished all Cheltenham, all Chowringhee, all Calcutta, could see him in that position, waving his hand to such a beauty, and in company with such a famous buck as Rawdon Crawley of the Guards.

William Makepeace Thackeray (from *The Book of Snobs*, 1848)

His mother, Lady Fanny Famish, believes devoutly that Robert is in London solely for the benefit of consulting the physician; is going to have him exchanged into a dragoon regiment, which doesn't go to that odious India; and has an idea that his chest is delicate, and that he takes gruel every evening, when he puts his feet in hot water. Her Ladyship resides at Cheltenham, and is of a serious turn.

Elizabeth Gaskell (from *Cranford*, 1853)

Mrs Jamieson went to Cheltenham, escorted by Mr Mulliner; and Lady Glenmire remained in possession of the house, her ostensible office being to take care that the maid-servants did not pick up followers. She made a very pleasant-looking dragon; and, as soon as it was arranged for her stay in Cranford, she found out that Mrs Jamieson's visit to Cheltenham was just the best thing in the world.

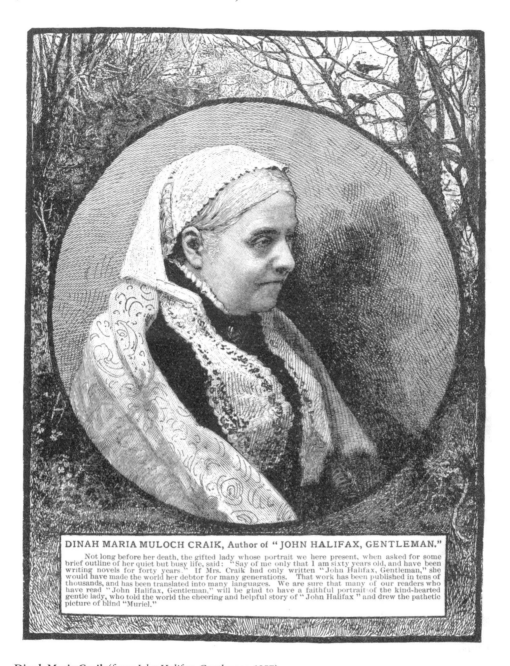

DINAH MARIA MULOCH CRAIK, Author of "JOHN HALIFAX, GENTLEMAN."

Not long before her death, the gifted lady whose portrait we here present, when asked for some brief outline of her quiet but busy life, said: "Say of me only that I am sixty years old, and have been writing novels for forty years." If Mrs. Craik had only written "John Halifax, Gentleman," she would have made the world her debtor for many generations. That work has been published in tens of thousands, and has been translated into many languages. We are sure that many of our readers who have read "John Halifax, Gentleman," will be glad to have a faithful portrait of the kind-hearted gentle lady, who told the world the cheering and helpful story of "John Halifax" and drew the pathetic picture of blind "Muriel."

Dinah Maria Craik (from *John Halifax, Gentleman*, 1857)

Before the curtain rose, we had time to glance about us on that scene, to both entirely new – the inside of a theatre. Shabby and small as the place was, it was filled with all the *beau monde* of Coltham, which then, patronized by royalty, rivalled even Bath in its fashion and folly. Such a dazzle of diamonds and spangled turbans and Prince-of-Wales' plumes. Such an odd mingling of costume, which was then in a transition state, the old ladies clinging tenaciously to the stately silken petticoats and long bodices, surmounted by the prim and decent *bouffantes*, while the younger belles had begun to flaunt in the French fashions of flimsy muslins, short-waisted – narrow-skirted.

Anthony Trollope (from *The Bertrams*, 1859)
The Littlebath world lives mostly in lodgings, and Miss Baker and Caroline lived there as the world mostly does. There are three sets of persons who resort to Littlebath: there is the heavy fast, and the lighter fast set; there is also the pious set. Of the two fast sets neither is scandalously fast. The pace is never very awful. Of the heavies, it may be said that the gentlemen generally wear their coats padded, are frequently seen standing idle about the parades and terraces, that they always keep a horse, and trot about the roads a good deal when the hounds go out. The ladies are addicted to whist and false hair, but pursue their pleasures with a discreet economy.

Anthony Trollope (from *Can You Forgive Her*, 1864)
Lady Macleod lived at No. 3, Paramount Crescent, in Cheltenham, where she occupied a very handsome first-floor drawing-room, with a bedroom behind it, looking over a stable-yard, and a small room which would have been the dressing-room had the late Sir Archibald been alive, but which was at present called the dining-room: and in it Lady Macleod did dine whenever her larger room was to be used for any purposes of evening company. The vicinity of the stable-yard was not regarded by the tenant as among the attractions of the house; but it had the effect of lowering the rent, and Lady Macleod was a woman who regarded such matters. Her income, though small, would have sufficed to enable her to live removed from such discomforts; but she was one of those women who regard it as a duty to leave something behind them, – even though it be left to those who do not at all want it; and Lady Macleod was a woman who wilfully neglected no duty. So she pinched herself, and inhaled the effluvia of the stables, and squabbled with the cabmen, in order that she might bequeath a thousand pounds or two to some Lady Midlothian, who cared, perhaps, little for her, and would hardly thank her memory for the money.

Anthony Trollope (from *Miss Mackenzie*, 1865)
She made a preliminary journey to that place, and took furnished lodgings in the Paragon. Now it is known to all the world that the Paragon is the nucleus of all that is pleasant and fashionable at Littlebath. It is a long row of houses with two short rows abutting from the ends of the long row, and every house in it looks out upon the Montpelier Gardens. If not built of stone, these houses are built of such stucco that the Margaret Mackenzies of the world do not know the difference. Six steps, which are of undoubted stone, lead up to each door.

John Nunn (from *Mrs Montague Jones' Dinner Party: or, Reminiscences of Cheltenham Life and Manners,* 1872)
[Mr Gustavus Jelly] sings a little, plays a little, flirts, rides, and dances; he considers himself quite an authority about ladies' dresses, has a great deal of small talk, and thinks that a watering-place like Cheltenham is the only fit place for a man to live in. [...] Mr Jelly is more ornamental than useful, and belongs to the non-laborious and non-industrial class, for they 'toil not, neither do they spin'.

4

ERUDITIO

When Cheltenham received its coat of arms in 1887 it chose *Salubritas et Eruditio* as its Latin motto, meaning 'Health and Learning'. *Eruditio* referred to its reputation as an educational centre of national importance. With three public schools and a wealth of other educational establishments, its fame as a town of learning spread far and wide, and in turn this helped to attract and nurture new writers. Many of these published personal experiences of receiving a Cheltenham education. For Cheltenham College this included autobiographies by Arthur Tuckerman and Patrick White, winner of the Nobel Prize for Literature in 1973, as well as the *Godfrey Marten, Schoolboy* series by Charles Turley set in the disguise of Cliborough College. For the Ladies' College this included reminiscences covering the personalities of their famous principals such as Dorothea Beale and Lilian Faithfull, as well as the account of 'an ordinary Cheltenham girl' being transformed into 'a Cheltenham Lady' in Elizabeth Gillard's autobiography.

Well-known poets who came to Cheltenham as students included James Elroy Flecker (see Chapter 1) who attended Dean Close, and Adam Lindsay Gordon (see Chapter 5) who became the national poet of Australia and was one of the first boys to enter Cheltenham College when it opened in 1841. Two lesser poets, A. J. Eardley Dawson and Cyril Winterbotham, also attended the college and shared the distinction of serving as officers during the First World War. Although Dawson survived the horror of the trenches, Winterbotham was tragically killed, his poem 'The Cross of Wood' ironically being published the day before he died.

Two well-known poets who came to Cheltenham as English teachers were U. A. Fanthorpe, who taught at the Ladies' College from 1962 to 1970, and C. Day-Lewis, who was appointed to Cheltenham College Junior School in 1930. The latter revealed in his autobiography, *Buried Day*, how, right from the start, he was greeted by the authorities at the conventional public school with suspicion on account of having 'committed poetry'. The formal relationship with his new employer worsened when he was reprimanded for wearing an old green shirt while whitewashing the walls of his house and then given another ticking off for wearing a stock with his dinner jacket at a concert. Worse was still to come when, a little later, the junior school headmaster questioned him about what he considered to be the 'excessively, er, SEXUAL' nature of the poems in his *Transitional Poem* collection, even though Day-Lewis protested that these were, in fact, love poems addressed to his wife. Despite this, his five years spent at the college were relatively happy, made more so through his close friendship with Lionel Hedges, a larger-than-life character who was not only the games and history master at the college but also a highly accomplished cricketer and actor. However, Day-Lewis's happiness was suddenly shattered when Hedges met an untimely death in 1933. In fact, he was so saddened that he felt as if his own blood was running out of him. He then made a lasting tribute to his friend through the title poem of *A Time to Dance*, which is regarded as one of his most highly acclaimed poems.

Charles Turley (from *Godfrey Marten, Schoolboy*, 1902)

When I went to Cliborough College I had, I think, two great advantages. The one was an enormous idea of my own importance; the other was an elder brother – he was at Sandhurst – who acted in accordance with his conviction that I was the most insignificant person in the world. [...] I had only been there two days when I found out that my brother had formed a much truer estimate of my importance than I had. From an important point of view I practically and promptly ceased to exist.

Charles Turley (from *Godfrey Marten, Schoolboy*, 1902)

'You can go to the schoolroom if you like, or you needn't,' I said; 'but if you don't you will have to fight me down here, and I happen to have been made a prefect this morning.'

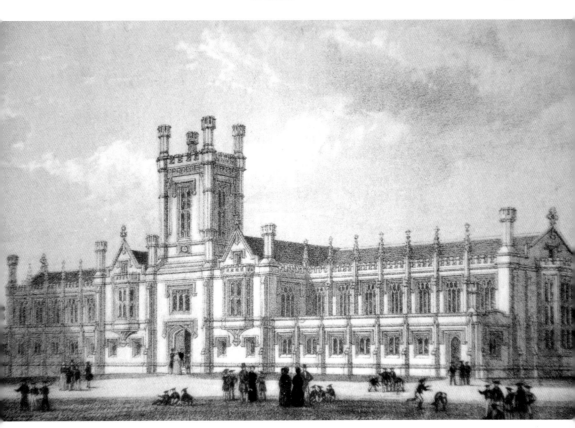

A. J. Eardley Dawson ('Cheltenham College I', in *Poems by a Cheltonian*, 1917)
When I have gone from thy protecting wing / To tread the stony, devious path of fate, / Through this proud world, its vanities and state, / The thought of thee will ever to me bring / A glow of pride, dear memories that cling; / But thou thyself rememberest but the great / Of thousands streaming slowly through thy gate, / Of these alone the praises wilt thou sing; / Yet humble and obscure, or men of fame, / We are content to worship at thy shrine, / For thou to all thy children art the same, / A mother worthy to be loved, divine; / We die, but thou wilt live an honoured name, / More brightly yet thy pure young Light shall shine.

A.J. Eardley Dawson ('Cheltenham College II', in *Poems by a Cheltonian*, 1917)
Long stand thy walls to honour more and more, / Thy sons who died thy growing name to raise, / Who died for thee that thou might'st be the praise / Of those that live when we have gone before, / That thou might'st nourish from thy golden store / Our children's children who in future days / Shall tread thy paths, ere yet they walk the maze / Which lies beyond the portals of thy door. / Foundation stone that shows the half-formed mind / The fuller structure of thy bounteous art, / So stern, severe, and yet for ever kind, / We learn thy teaching most when we must part; / 'Tis now, when we have left and gone, we find / That thy dear name lies graven in the heart.

Cyril Winterbotham ('The Cross of Wood', *Fifth Gloucester Gazette*, 1916)
Not now for you the glorious return / To steep Stroud valleys, to the Severn leas / By Tewksbury and Gloucester, or the trees / Of Cheltenham under high Cotswold stern. / For you no medals such as others wear – / A cross of bronze for those approved brave – / To you is given, above a shallow grave, / The Wooden Cross that marks you resting there. / Rest you content, more honourable far / Than all the Orders is the Cross of Wood, / The symbol of self-sacrifice that stood / Bearing the God whose brethren you are.

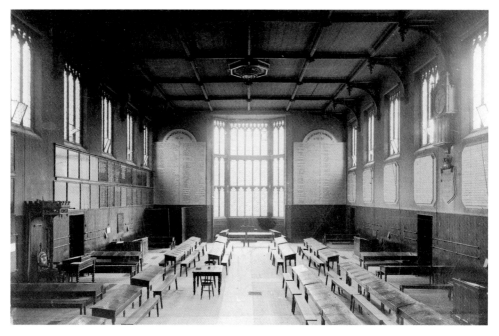

Arthur Tuckerman (from *The Old School Tie*, 1954)

The next day, properly attired, I sat at an ancient desk crisscrossed with the initials of generations of Cheltonians in a formidable hall known as the Great Classical. It was the focal point of the School, and all great events took place in it.

Patrick White (from *Flaws in the Glass: a Self Portrait*, 1981)

Our days and nights in the house in which I was boarded revolved round the 'sweatroom' where we did our prep and led the little social life we enjoyed in an English public school. My first impression of this sweatroom was one of varnish and carbolic, together with the smell of radiators you could press against for warmth if you were lucky enough to have one alongside your desk.

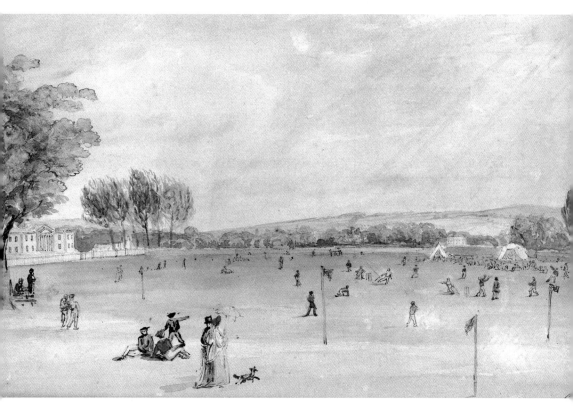

C. Day-Lewis (from *Buried Day*, 1960)

During the couple of days we stayed in Cheltenham for my interview, the headmaster, H. H. Hardy, took me for a long country walk in the course of which he sounded me about my views on D. H. Lawrence. As it so happened, I had read a good deal of Lawrence recently, and been much impressed by *Sons and Lovers*, *Women in Love* and *The Rainbow*; but instinct warned me not to praise them too rapturously, and in particular to avoid a discussion of their sexual ethic. [...] Cheltenham was a highly conventional public school, and I was known to have committed poetry, and the headmasters of conventional public schools are likely to be wary – and with some justification – of young poets, especially when they mask their potential subversiveness behind short hair and a keen interest in games.

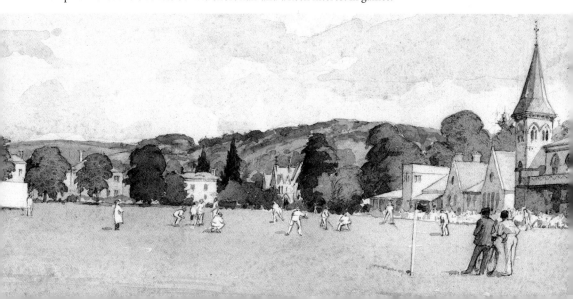

Annabel Huth Jackson (from *A Victorian Childhood*, 1932)
When we went into the little house alongside the College, and the grave, rather beautiful woman rose to receive us, I realized that in Miss Beale there was something a little different, something not common, something apart. She was short, but her dignity was marvellous. The only person of her generation whose dignity was greater was Queen Victoria. She had large penetrating eyes and great humour in the corners of her mouth. She walked with an extraordinarily smooth long step, it must have been because she wore no heels.

Lilian Faithfull (from *In the House of My Pilgrimage*, 1924)
One of the deepest impressions made on me was that the College was a place full of extraordinary achievement and extraordinary possibilities, and I never lost this feeling throughout my fifteen years' work at Cheltenham. I know nothing more stimulating to a newcomer. It was easy also to realise that a spirit of happiness pervaded the College, and I can imagine nothing more refreshing as one grows older than to work in the midst of a swarm of children, eager and enjoying.

Elizabeth Gillard (from *The Tale of a Cheltenham Lady*, 2009)
I should have gone to the local grammar school – that would have been far more straightforward. But it wasn't to be. Fate intervened, in the form of an ancient source of revenue; a summit was called and a decision taken. Whether I liked it or not, I was to be educated at Cheltenham Ladies' College, if it would accept me, in the town of my birth, destined to start a journey intended to transform me from an ordinary Cheltenham girl to a Cheltenham Lady.

5

SPORT

In Nico Craven's *Waiting for Cheltenham* (1989), the author of more than thirty books about county cricket threw down the gauntlet to Irish racegoers in reasserting that there is more than one Cheltenham sport festival. The 'waiting', he said, begins as soon as the 'last race has been run and the last man run out'. While writers have also highlighted Cheltenham's long association with other types of sport, for example football (Cheltenham Town FC, founded in 1887) and croquet (Cheltenham Croquet Club founded in 1869), it is the four-day National Hunt Festival and the eleven-day Cricket Festival which have featured most prominently in literary texts through the ages.

The Cheltenham Races were first held in 1818 on Cleeve Hill, and the first Gold Cup in the following year. They proved so successful that, despite several attempts by the Revd Francis Close to stop them, they have continued to flourish until the present day. Over the years, numerous writers have celebrated the special atmosphere and excitement of the races. These have included racing thriller novelists Dick Francis, Jenny Pitman, John Francome and Lyndon Stacey, as well as the poet John Masefield who famously referred to the Gold Cup as occasionally being won by 'the worst horses' in his inspiring four-line poem about trust entitled 'An Epilogue'. However, the earliest poet to write about the races was Adam Lindsay Gordon who witnessed the first steeplechase in 1847 when it was held on the gruelling Noverton Lane course. Unfortunately, on this occasion one of the horses was killed through hitting a tree and his rider narrowly escaped death. This made a deep impression on Gordon, who was thirteen at the time, and the experience later inspired him to write 'How we Beat the Favourite' in which he imagined himself riding the mythical horse 'Bay Iseult' to win against 'The Clown' by 'a short head'. Although he used poetic licence in this poem, Gordon himself was an accomplished rider, and rode in the Berkeley Hunt Cup Steeplechase at Prestbury in 1852. A year later he emigrated to Australia and became not only a famous steeplechaser but also Australia's national poet. Nevertheless, he continued to remember Cheltenham through poems such as 'Ye Wearie Wayfarer' in which he not only recalled 'the mist on the Cotswold Hills / Where I once heard the blast of the huntsman's horn' but also the ringing bells of 'Sweet St. Mary's / On far English ground'.

Cheltenham's Cricket Festival, on the other hand, was originally established in 1872 and, like the races, has become an automatic fixture in the calendars of devoted followers. Avid supporters included Nico Craven, who for thirty-four years chronicled every aspect of the game. Other writers to find inspiration at the College cricket ground have been P. G. Wodehouse who discovered his 'Jeeves' and Lillah McCarthy, the actress, who found her childhood idol in the Cheltenham-born cricketer Gilbert Jessop, only for it to be shattered when she saw him bowled out for a golden duck while playing for England against Australia.

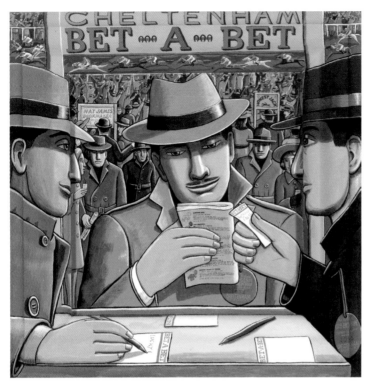

Francis Close (from *A Letter Addressed to the Inhabitants of Cheltenham...*, 1830)

My Dear Friends,

I have recently been much affected by reading in the Cheltenham Papers some instances of the fatal effects of attending the Races at Bath and Ascot and it struck me that if these circumstances were generally known they might be the means of preventing many of you from attending the Races, which will shortly be held in this town: and I am so deeply convinced of the injurious tendency of such pursuits, both with respect to your temporal and eternal interests, that I would embrace every opportunity of dissuading you from having any thing to do with them.

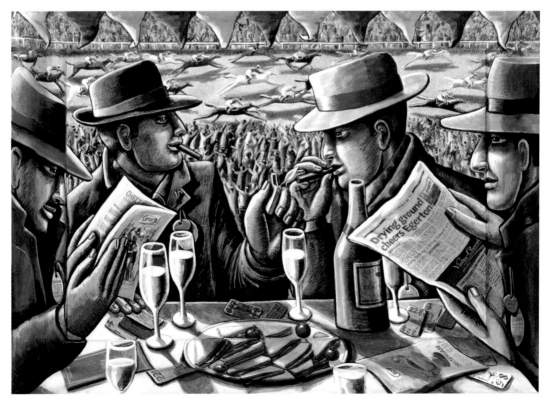

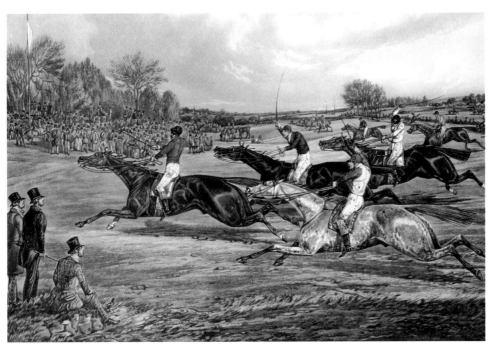

Anon. (from *Cheltenham Races: a Poetical Description*, 1820)
Weep Kingscote, weep, thy raining glory's o'er; / Let Bibury boast her matchless sport no more: / Thro' Gloucester's vale let Cheltenham's fame resound, / And prince of courses Cheltenham's course be crown'd!

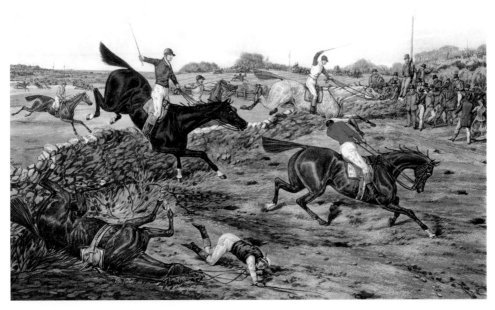

Adam Lindsay Gordon (from 'How We Beat the Favourite', 1869)
A rise steeply sloping, a fence with stone coping – / The last – we diverged round the base of the hill; / His path was the nearer, his leap was the clearer, / I flogg'd up the straight and he led sitting still.

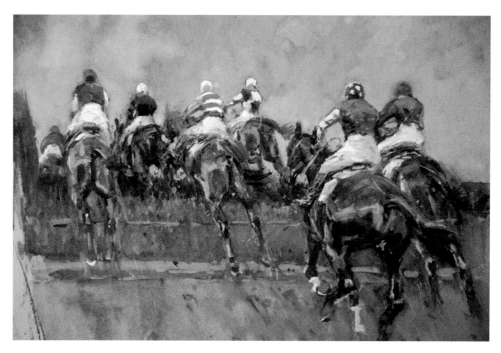

Robert Benchley (from 'They're Off!', *Liberty Magazine*, 1930)

Then, too, there are the English race courses. Even if you could see through the fog, you couldn't find them, as they seem to be built on the tunnel system. 'Not a horse in sight' is their boast. Watching races in England is more a matter of divination than actual watching. You have to sense where the horses are. I was at the Cheltenham meeting this spring where the horses evidently started under the grandstand, appeared for a minute in a little gully out in right field, and then disappeared for good into the beautiful hills of Gloucestershire. [...] As it happened to be a clear day (with only occasional gusts of snow and rain) you could see the finish. That is you could. I couldn't, because I was out in a tent behind the grandstand eating meat pies.

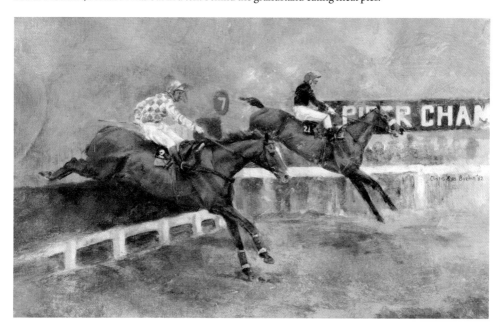

Lyndon Stacey (from *Outside Chance*, 2005)

It looked as though the day of the Cheltenham Gold Cup was going to be just one more wet and windy day in a wet and windy week, but by mid-morning the heavy grey blanket of cloud had separated in places to allow the March sunshine through. By noon the sky was clear and very blue.

As the weather lifted, so did the spirits of the racegoers, and it was a large and noisy crowd that gathered to witness one of the most important day's racing in the National Hunt calendar. Smart casuals made of corduroy or tweed were topped off with an assortment of hats, ranging from the stylish to the purely functional and, at ground level, the occasional pair of high heels slipped and slithered through the mud next to the more sensible stout shoes and wellies.

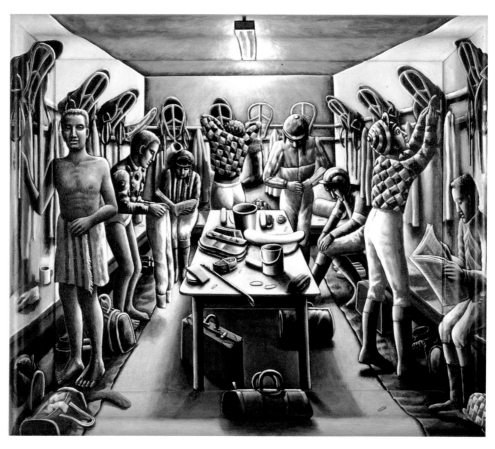

John Hudson (from *A Year in the Cotswolds*, 1995)

I have never discovered which came first, the Irish flocking to Cheltenham because the Gold Cup meeting falls on or near March 17, or the timing of the meeting to coincide with St Patrick's Day so as to lure them over. Whatever the original thinking, it has produced an event with a very special chemistry, a National Hunt showpiece joyfully more intimate and rural in spirit than Liverpool's Grand National.

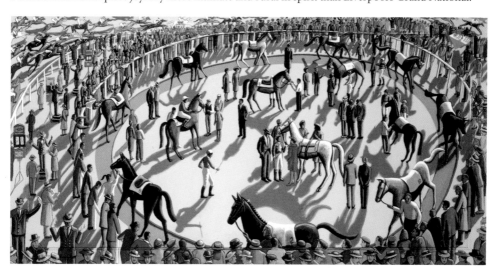

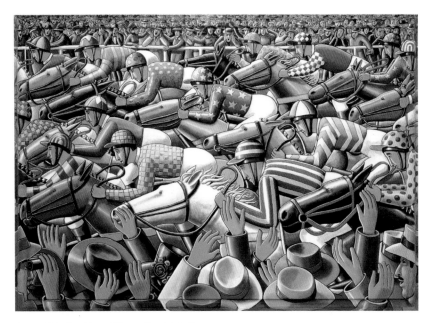

Henry Birtles (from 'Dawn Run', 2002)

In sport there are great athletes who've triumphed without fame / Whose achievements aren't reflected by the level of acclaim / Though Cheltenham crowds laud champions as part of their vocation / The scenes that day, with victory sure, trumped all known celebrations

The Irish were delirious, the English joined their ranks / Strangers hugged and hats were lost, Clergy danced with cranks / The wave that she'd created now exploded without shame / As undistilled elation placed the Mare beyond this game

A statue now bears witness to the feat Dawn Run achieved / Across her scene of triumph, everlasting gaze bequeathed. / Through spirit, skill and fortitude, she set the pulse apace / Her memory will be feted for as long as horses race

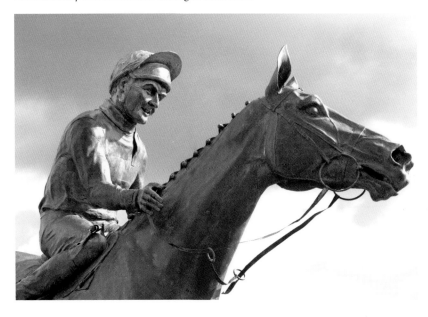

Lillah McCarthy (from *Myself and My Friends*, 1933)

I go to see the cricket at Cheltenham School. Gilbert Jessop becomes my hero; there is nothing restrained about him, hitting 'sixes' all over the field. I become a bowler: fast overhand. I should like to bowl him out. But later my idol failed me, as is the way of idols. It was in Australia. England *versus* Australia. All Australia was there. I was with Australian friends. The game was going against us. 'Wait,' I told them; 'wait until Jessop comes in.' He came in, faced the bowler, gave a mighty slash at the ball. Missed! Clean bowled! My friends cheered, but I furtively wiped away a tear.

P. G. Wodehouse (from a letter to R. V. Ryder, 26 October 1967)
It must have been in 1913 that I paid a visit to my parents in Cheltenham and went to see Warwickshire play Glos on the Cheltenham College ground. I suppose Jeeves' bowling must have impressed me, for I remembered him in 1916, when I was in New York and just starting the Jeeves and Bertie saga, and it was just the name I wanted. I have always thought till lately that he was playing for Gloucestershire that day (I remember admiring his action very much).

Warwick Deeping (from *The Impudence of Youth*, 1946)
Sybil had experienced the crabbed and confined routine of both Cheltenham and St. Leonards, where a colonel's widow devoted herself to making a pension suffice and to playing croquet. Sybil loathed croquet. It was a mean, sneaking sort of game suited to old people's cunning. She had colour and temper, and perhaps she preferred Lawrie's crude killing of things to the crowding of balls through hoops.

Zoë Barnes (from *Hitched*, 1998)
Back in the old days, the lads used to call in at the Red Horse on the way back from watching Cheltenham Town lose five-nil. Ninety minutes of mental and physical torture, huddled on the freezing terraces with a couple of hundred other sad young men. Now that was football: the wind, the rain, the camaraderie, the cold pies. Of course, these days the Robins were rather good, and the pies were hot, and it just wasn't the same.

6

MUSIC

In Howard Jacobson's *No More Mister Nice Guy* (1998), the TV critic Frank Ritz flees from the strained relationship with his partner to Cheltenham. He stays at the Queen's Hotel watching *Friends* on the television in his room and then thinks about going to see some 'cultivated entertainment' such as a chamber concert, or a J. B. Priestley or Terence Rattigan play. But instead he ends up queuing outside a theatre to see a fat stand-up comedienne. This chain of events perhaps shocks the reader all the more because it takes place in Cheltenham of all towns, a place that is usually synonymous with prestigious festivals celebrating the finest music and literature.

Cheltenham's musical pedigree can be traced back to its development as a spa and fashionable inland resort served by a plethora of musical groups. Handel was one of the well-known composers who came only for a health cure, a friend urging him during his last visit not to stay too long in case he neglected finishing the oratorio *Jephtha*. Other composers such as Liszt came to give performances as part of their tours, despite Cheltenham's reputation of having once thrown Paganini, 'the greatest violin player that ever existed', out of town. Rather bizarrely, Liszt's 'spirit' was reawakened in the mid-1950s, when Cheltenham became home to an eccentric pianist known as Vladimir Levinski.

More famously, Cheltenham is remembered as being home to Gustav Holst and Brian Jones, two outstanding artists at opposite ends of the musical spectrum. Gustav Holst was born at 4 Clarence Road, which now houses the Holst Birthplace Museum. His father, Adolph von Holst, taught music at Cheltenham Grammar School and the Ladies' College, gave piano recitals at the Assembly Rooms, and was organist at All Saints' church. Gustav began composing at the age of twelve and completed many hundreds of works, *The Planets* being his best-known piece. Cheltenham has always celebrated its association with Holst, one of its most distinguished sons, not least in 2008 when a memorial fountain and statue were erected in Imperial Gardens. The town also paid tribute to him by organising a festival of his works in 1919. Despite being in frail health Holst himself was able to conduct the whole performance of *The Planets* and during the interval was given a painting of Saturn, Neptune, Jupiter and Venus as seen from the top of Cleeve Hill on May 1919. Holst described this as 'the most overwhelming event of [his] life'.

In 2005 Cheltenham also celebrated its association with a very different musician when a bust of 'Golden Boy' Brian Jones, the founder of The Rolling Stones, was unveiled. Jones was born in Cheltenham, attended both Dean Close Preparatory and Pates Grammar School, and played with many Cheltenham-based bands before placing an advert to start The Rolling Stones rock group, the name being derived from a Muddy Waters song. His funeral was also held in Cheltenham, at St Mary's parish church, after he tragically drowned under mysterious circumstances in a swimming pool.

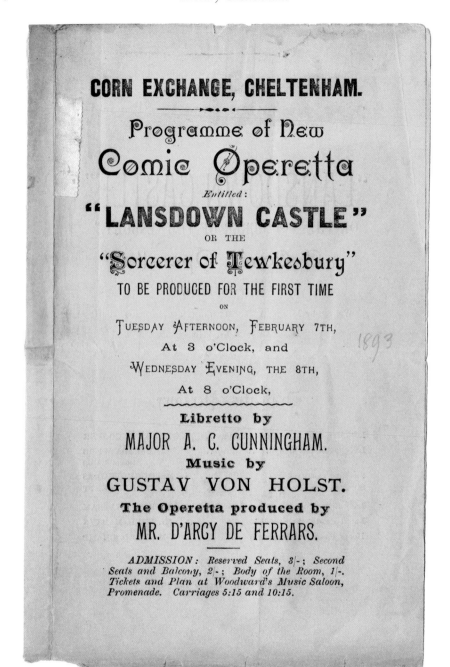

The new comic operetta *Lansdown Castle,* **at Cheltenham**
As a teenager Holst composed the operetta *Lansdown Castle,* the original 'castle' being a crenellated tollgate which stood at the corner of Lansdown Road and Gloucester Road. At its inaugural performance expectations were high that the town was about to witness an exceptional talent. Expectations were fully realised: the music was described, according to the *Gloucester Chronicle* on 11 February 1893, as 'remarkable and not unworthy of a trained and experienced musician', and the composer's melodies were praised as 'always flowing, tuneful, expressive, and free from conventionality'.

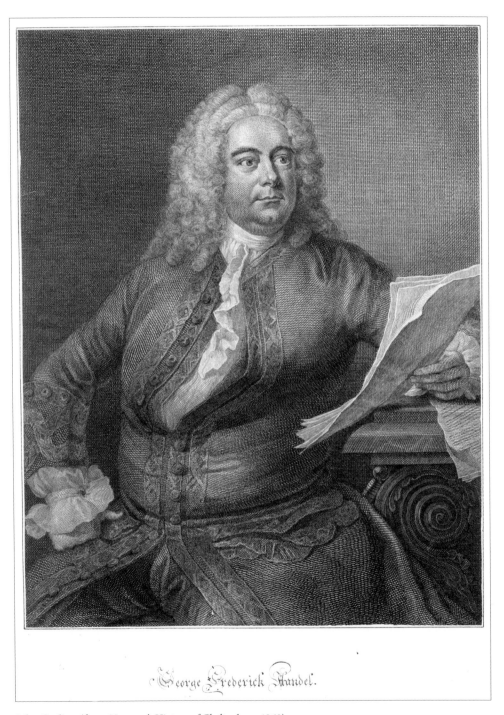

George Frederick Handel.

John Goding (from *Norman's History of Cheltenham*, 1863)

Handel, whose divine *Messiah* has immortalised him to all future generations, sought the invigorating air and medicinal waters of Cheltenham to strengthen his frame after intellectual application. According to the *Gentleman's Magazine*, it was in 1744, after the completion of this most magnificent composition, that the great man was a visitor.

Paganini (from 'Miscellanea' in *The Athenaeum*, 30 July 1831)
Paganini has been (he would say) sadly ill-used at Cheltenham. His performance was announced at double playhouse prices, himself to pocket two-thirds of the proceeds – but, finding the house not half full, he refused to play unless paid two hundred guineas beforehand: this the manager declined doing, and acquainted the audience of the circumstances, which created such a tumult, that a party beset the Signor in his hotel, and he was at length obliged to perform, and at ordinary prices – but the total receipts being little more than enough to cover the expenses, the fiddler did not even get a sixpence.

Franz Liszt (from *Cheltenham Journal*, 7 September 1840)
The first concert took place at the Assembly Rooms last Friday evening, Liszt, as was anticipated, forming the principal attraction. It is impossible to give our readers an adequate idea of the consummate taste and execution of this artist; whether in his silvery piano passages or in his *con furia* movements, he stands unrivalled. We had no conception before last Friday, that so much could be made out of one pianoforte. The rushing of an avalanche down a stupendous rock, the rolling of the mighty thunder, or the roaring of the sea in its most troubled moments might all be adduced as types of the tempestuous portions of his fantasias; nor in a flash of lightening, an overcharged simile of the rapidity with which he changes the character of the harmony from one style to another. We went prepared to hear a wonder, but our expectations were more than realized; the company seemed entranced, and made the Assembly Rooms ring with their plaudits; their encores were modestly and readily granted. Liszt, in his 'recitals' more particularly, seems to hold converse with his instrument, he imparts, as it were, a soul to the keys and wires of his piano; and, as with his long forked fingers, he takes his winged flight over them, draws out in reply any sort of answer which may please the fancy uppermost in his mind.

John Appleby (from *38 Priory Street (and All That Jazz)*, 1971)
I refer … to the tall, elegant figure of Vladimir Levinski who, to the delight and astonishment of many contemporary Cheltonians, claimed to be the re-incarnation of Liszt. […] As a pianist, audiences found him both brilliant and temperamental. There was the occasion when he 'took' the Cheltenham Town Hall one night and proceeded to give a magnificent performance. But, for some reason better known to himself, he was displeased and strode off the stage halfway through the concert, throwing sheets of music about him as he left.

Imogen Holst (from *The Music of Gustav Holst*, 1951)
In one of Holst's letters to Vaughan Williams, written only a few months before he died, he mentioned 'the first definite idea of life' he had learnt while still in his cradle: 'namely, that music is a nice thing'. He had learnt this in the small house in Cheltenham that is now the Holst Birthplace Museum.

Gustav Holst (from a letter to W. G. Whittaker, 1924)

For many years I have tried to write a piano piece for Mrs O'Neill and this summer I have at last succeeded ... In the first variation I seem to have 'sincerely flattered' you for which I ask your permission and your pardon. At the end I have 'flattered' the first man who ever played it to me. He was an old man in Cheltenham with a hurdy-gurdy, somewhere about 1879, and this was his only tune and each time he played it he had fewer notes than before and what notes were left were further from what they were when they were young.

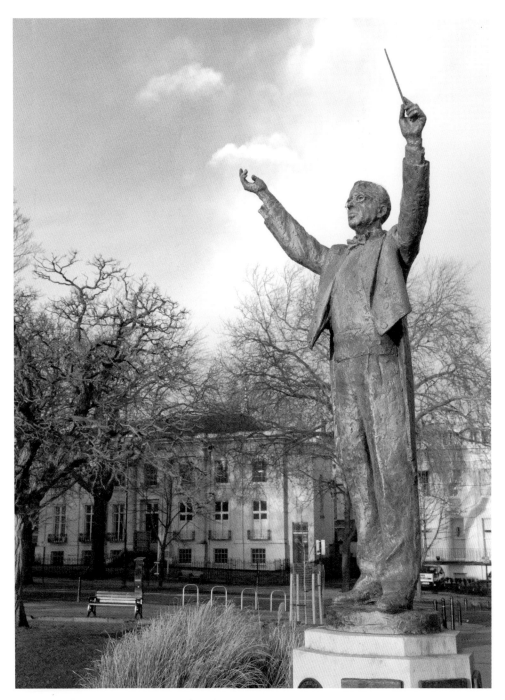

Imogen Holst (from *Gustav Holst: a Biography*, 1938)
The citizens of his native town of Cheltenham had an original idea. Instead of waiting until he died, and then putting up a stone monument to his memory, they decided to honour him while he was still living. They organized a Holst Festival, and hired the City of Birmingham Orchestra, and gave a concert of his works in the Town Hall. […] When it was all over, Holst wrote to his friend Austin Lidbury: *Dear Lid, I send you a programme of the most overwhelming event of my life.*

Rob Weingartner (from 'A Tribute to Brian Jones', 2008)

To try and understand Brian Jones you must go back to his childhood in Cheltenham, for this is where his love for music started and his problems began. Although the town had its unquestionable beauty, there were not many places for young people to go at the time except local coffee bars like the El Flamenco or to the cinema. However, one of the places Brian would frequent quite often was 38 Priory Road – the home of Mrs Filby, who would allow the basement of her home to be used as social gatherings for local teenage kids. Like most kids his age Brian Jones thought of Cheltenham as a dull and boring town. What Brian wanted was excitement, something Cheltenham seemed to lack. Future fellow band mate Keith Richards once described Cheltenham as a 'very genteel old ladies' resting place; very pretty in its way, but dullsville'.

In 1947, at the age of five, Brian began attending Dean Close Junior School in Cheltenham. Brian's interest in music began to show at a very young age. At around six or seven Brian started piano lessons and later at the age of twelve while attending Pates Grammar School, Brian joined the school orchestra and learned clarinet. Brian's school teachers noticed very early on that he was a brilliant student who passed school examinations with virtual ease and had an exceptionally high IQ. Brian was described by former Pates Grammar School teacher Dr Arthur Bell as an 'intelligent rebel'. [...] Years later, reflecting on his early interest in music Brian said 'Musically, I was guided by my parents. Later, there were several piano teachers in Cheltenham. I struggled to get the notes right early on, but eventually I found I had a feel for music. I guess I knew that I was going to be interested in music early on and that was because I quite honestly didn't feel much of an urge to do anything else.' Brian did try some jobs while living in Cheltenham such as junior architect, a bus conductor, and he worked in a music shop and even delivered coal for a short while. None of which interested Brian nor lasted very long. In his mid-teens Brian became obsessed with music – most notably American Rhythm and Blues music. After attending a concert at the Cheltenham Town Hall to see Alexis Korner's band, Blues Incorporated, he wanted to take music more seriously and left Cheltenham in early 1962 for London realizing he would have a better chance of forming a Rhythm and Blues band, as that's where all the Blues clubs were. Within months of Brian's departure from Cheltenham, on July 12, 1962, The Rollin' Stones would play their first gig at the Marquee Club in London and soon the rest would be history.

7

TRADE AND INDUSTRY

According to Colin Howard, author of *Cotswold Days* (1937), while Gloucester works hard for its living, 'Cheltenham does not talk much about money, but genteelly assumes you have it.' Certainly, Cheltenham has never been primarily an industrial town, nor with its popularity as a favoured place for retirement has it always benefited from a large population in active employment. Laurie Lee humorously observed this in *As I Walked Out One Midsummer Morning* (1969) when he wrote, 'Worthing at that time was a kind of Cheltenham-on-Sea, full of rich, pearl-choked invalids. Each afternoon they came out in their high-wheeled chairs and were pushed round the park by small hired men.' However, Cheltenham has never just consisted of 'rich, pearl-choked invalids' and 'small hired men'. From the first half of the nineteenth century, when it developed its reputation as a first-class shopping centre, to the present day, where at Government Communications Headquarters (GCHQ) some of the world's greatest problem-solving and analytical minds are located, Cheltenham has continued to find prosperity through a plethora of different trades, many of which have found inspiration or reflection in works of literature.

Some examples of these include tobacconists (Dickens), dressmakers (Ashton), chimney sweeps (Noyes), potters (McCall Smith), stamp dealers (Brenan), and antique dealers (Lee). Also, the food industry has been represented in a selection of historical cookery books which provide the original recipes for Cheltenham Cakes and Cheltenham Pudding, the production of which is still kept alive today by local bakers.

However, one of the more unusual literary links arises through the secret world of cryptography and signals intelligence on account of the town's association with GCHQ since 1952, which today constitutes its largest employer. Not only has this brought Cheltenham firmly into the spy thriller genre through authors such as Frederick Forsyth, but it has also prompted literature from the detective genre to be selected for use within an artwork commissioned for GCHQ's new 'doughnut' headquarters building. The work itself, a cast glass sculpture known as 'The Cipher Stone', was inspired by the Rosetta Stone, an ancient symbol of the cryptographer's ability to find meaning in obscure text. It contains four visible texts derived from Edgar Allan Poe, Sir Arthur Conan Doyle, G. K. Chesterton and the lesser-known Fred M. White. The incorporated texts from G. K. Chesterton reflect GCHQ's expertise by focusing on the use of specialised analytic techniques to the benefit of society. There are three versions of each text: encrypted, decrypted into the language of the cipher (in this case Russian) and an English translation. The G. K. Chesterton quotation also reflects GCHQ's ability to find 'a needle in a haystack' and to look beyond what is obvious – referring, in particular, to the work of cryptanalysts at GCHQ today and its forerunner at Bletchley Park. Although GCHQ's Cipher Stone is not on public display, a replica of the stone is now accessible to the public after it was donated to Bletchley Park in October 2012, following a visit from the Foreign Secretary.

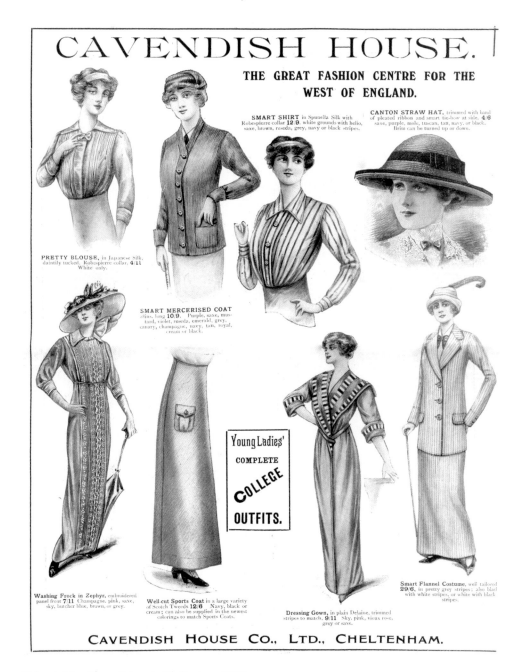
Helen Ashton (from *Return to Cheltenham*, 1958)

'Ally must have a new dress from Cavendish House,' she decided, 'and so must I ...' [...] So they walked down the Promenade next morning to the old-established draper's shop, Cavendish House, and were measured for new gowns by a black-silken dressmaker in a fitting room lined with looking-glasses. Mrs Brendan ordered a ball-dress in the latest fashion, of pink-and-grey shot silk, in the shade called gorge-de-pigeon, and a wreath of the same to bind her yellow hair.

Charles Dickens (from *The Life and Adventures of Nicholas Nickleby*, 1838–1839)
'I had an uncle once, Madame Mantalini, who lived in Cheltenham, and had a most excellent business as a tobacconist – hem – who had such small feet, that they were no bigger than those which are usually joined to wooden legs – the most symmetrical feet that even you can imagine.'

Alfred Noyes (from 'The Chimney-Sweeps of Cheltenham', in *The New Morning*, 1918)
For the chimney-sweeps of Cheltenham town, / Sooty of face as a swallow of wing, / Come whistling, singing, dancing down / With white teeth flashing as they sing.

Gerald Brenan (from *A Life of One's Own: Childhood and Youth*, 1962)
To raise more money I decided to sell ... my stamp album. [...] I took it to a shop in Pittville Street, Cheltenham, kept by a little man with white hair, chubby cheeks and steel-rimmed spectacles, who went by the name of Mr Pink. I had often bought stamps from him in the past and, as he was such a crushed little man and had such a wheezy, asthmatic voice and such a mild, timid air, I imagined that, when I told him that I needed the money urgently and in a great hurry, he would deal with me honestly. But from the first moment difficulties arose that I had not anticipated. He was not knowledgeable on stamps, he declared: he must show my collection to a man who would value it for him. If I came back in a few days he would make me an offer. Pressed for time though I was, I felt it best to agree to this. However, when I returned three days later, he said in his wheezy voice – he seemed to be in an even worse state of health than usual – that the most he could give me was £6. As such a sum seemed far too small – I was expecting between £12 and £20 – I asked for the album back, only to be told that the valuer still had it and that he had gone away for a fortnight. I was left with no option but to close and take what he offered me. But at once a new difficulty cropped up. Mr Pink could only give me £1 in cash and asked me to come back at the end of the week for the rest. Again I had to agree. I was in his power completely. However, when I returned he was still without money – the week had been a dead loss – his rent was still owing – the wheeze worse than ever – so he suggested that I might select from his secondhand books a number sufficient in value to meet the amount he owed me. Once more I had to do what he wanted. I chose Rawlinson's *History of Assyria*, *The Book of Mormon*, a work entitled *An Explanation of King Solomon's or the Greater Seal*, a history of Freemasonry, *A History of Gloves through all the Ages*, with illustrations, and left the outstanding amount to be collected at some future date. None of these books except the first had much interest for me, but Mr Pink's library did not offer a wide choice.

Laurie Lee (from *Cider with Rosie*, 1959)

In this way and others, we got some beautiful china, some of it even perfect. I remember a Sèvres clock once, pink-crushed with angels, and a set of Crown Derby in gold, and some airy figures from Dresden or somewhere that were like pieces of bubble-blown sunlight. It was never quite clear how Mother came by them all, but she would stroke and dust them, smiling to herself, and place them in different lights; or just stop and gaze at them, broom in hand, and sigh and shake with pleasure. [...] She couldn't keep any of them long, however. She just had time to look them up in books, to absorb their shapes and histories, then guilt and necessity sent her off to Cheltenham to sell them back to the dealers.

Alexander McCall Smith (from *Corduroy Mansions*, 2009)
Of course, Cheltenham was slightly different. It was a place where people went to the races or retired to or came to make and sell pottery. And not all of these people would be free of the neuroses they had brought with them from somewhere else. So perhaps she might not be completely without something to do after all.

Charlotte Mason (from *Mrs Mason's Cookery, or the Ladies' Assistant*, 1786)
To make Cheltenham Cakes. Take four pounds of flour, half a pound of butter, melt it in a pint of milk, two eggs well beat in half a pint of yeast, a little salt; mix it well together, and set it before the fire to rise three-quarters of an hour; make them up, and set them again before the fire to rise, before they are set into the oven. Three-quarters of an hour will bake them in a quick oven.

Cheltenham Pudding (from *The English Cookery Book*, edited by J. H. Walsh, 1859) Mix three-quarters of a pound of flour, half a pound of suet chopped very fine, half a pound of currants, two or three eggs, two or three ounces of sugar, half a pint of milk, or enough to make the pudding thicker than batter, but thinner than dough; mix the dry ingredients first, beat the eggs and milk together, then mix all. Bake an hour and a quarter, or half.

Cheltenham Pudding (Modern Version) (from *www.visitcheltenham.co.uk*)
Ingredients for Cheltenham Pudding
2 tablespoons golden syrup, 4 ounces (120 grams) butter, 4 ounces (120 grams) soft brown sugar, 2 beaten eggs, 6 ounces (180 grams) SR flour, 2 tablespoons milk, 2 pears or 2 small cooking apples, 2 ounces (120 grams) mixed dried fruit, 2 ounces (120 grams) demerara sugar, 1 teaspoon cinnamon.
How to Make Cheltenham Pudding
Butter a 2 pint pudding basin and pour in the syrup. In another bowl, beat the butter with the soft brown sugar and add eggs gradually, followed by the flour and milk. Peel and chop the fresh fruit and in a third bowl mix with the demerara sugar and cinnamon. Layer these two mixtures over the syrup, beginning and ending with the pudding mix. Cover and steam for two hours. Turn out and enjoy, with lashings of custard!

G. K. Chesterton (from 'The Sign of the Broken Sword', in *The Innocence of Father Brown*, 1911)
[Quotation included on The Cipher Stone at GCHQ, Cheltenham]
'Where does a wise man hide a pebble?'
And the tall man answered in a low voice: 'On the beach.'
The small man nodded, and after a short silence said: 'Where does a wise man hide a leaf?'
And the other answered: 'In the forest.'

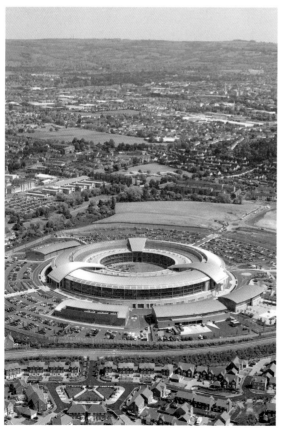

The Rt Hon. William Hague MP (from 'Foreign Secretary's Speech at Bletchley Park', 18 October 2012)
Without the code-breaking geniuses of Bletchley Park our country would have been at a devastating disadvantage during the war. And without the men and women of GCHQ and our other intelligence agencies we could not protect Britain today. There is an unbroken chain connecting their achievements.

CREDITS

Picture Credits

I should like to thank the following for granting me kind permission to reproduce from copyright or privately owned material.
p. 4 The Headmaster, Cheltenham College, for the manuscript version of 'Cheltenham' illustrated by John Betjeman; p. 6 The New Club, Cheltenham, for 'Cheltenham', by Pauline Burdett; p. 8 (top) 'West Prospect of the Spa and Town of Cheltenham' by Thomas Robins (1716–1770) © Cheltenham Art Gallery & Museum; p. 8 (bottom) The Headmaster, Cheltenham College for 'Cheltenham from the Crippetts' by Edward Wilson (1872–1912); p. 9 (top and bottom) The Headmaster, Cheltenham College; p. 10 Charles Dickens (1812–1870) © Cheltenham Art Gallery & Museum; p. 11 (top) The Headmaster, Cheltenham College for 'Cheltenham from the Crippetts' by Edward Wilson (1872–1912); p. 11 (bottom) The Headmaster, Cheltenham College, for 'Snow storm over Cheltenham' by Edward Wilson (1872–1912); p. 12 The Piper Estate for 'Cheltenham Fantasia' by John Piper (1903–92) © Cheltenham Art Gallery & Museum; p. 14 (top) The Headmaster, Dean Close School, for 'The elms in *November Eves*'; p. 14 (bottom) Cheltenham Library service for 'The Promenade, Cheltenham' c. 1860 (Catalogue Ref. Box B/PR7/14); p. 15 Elizabeth Gillard for '5 Suffolk Square (September 1942)'by Air-Commodore Masterman; p. 20 (top and bottom) 'Cheltenham Floods 2007' © Catrin Elder; p. 22 Cheltenham Library service for 'The Promenade, Cheltenham' (Catalogue Ref. Box B/PR7/9); p. 25 The Edward Jenner Museum for 'Edward Jenner (1749–1823)'; p. 26 Portrait of Lord Byron painted by G. Sanders 1807, engraved by R. Soper © Private collection; p. 27 Trinity College, University of Cambridge, for 'Alfred Tennyson (1809–1892), 1st Baron Tennyson, Honorary Fellow (1869), Poet Laureate' by George Frederic Watts; p. 28 (top and bottom) The Headmaster, Dean Close School, for 'Francis Close' (1797–1882) and 'Francis Close and Family 1836'; p. 29 The Headmaster, Dean Close School, for Francis Close's Bible; p. 31 The University of Liverpool Library for 'Portrait of Josephine Butler' [JB 1902.12.13 (I)]; p. 32 The Headmaster, Cheltenham College; p. 33 © Private collection; p. 34 The Headmaster, Cheltenham College, for 'Portrait of Edward Wilson' (1872–1912) by Hugh G. Riviere; p. 35 The Headmaster, Cheltenham College; p. 36 (left) The New Club, Cheltenham, for 'Portrait of W. G. Grace' (1848–1915); (middle) The Headmaster, Dean Close School for 'Portrait of Rev. Francis Close' (1797–1882); (right) 'Gustav Holst as a young boy with violin' © The Holst Birthplace Museum; p. 39 'His Most Sacred Majesty George III, King of Great Britain' courtesy Library of Congress; p. 40 (top) The Borough Council of King's Lynn & West Norfolk for 'Fanny Burney' (1752–1840) by Emil Veresmith; (bottom) Cheltenham Library Service for 'Mrs Forty and Mrs Rous: Pumpers at the Well' (Catalogue Ref. Box A/PR3.1CE); p. 41 (top) © Private collection; (bottom) Cheltenham Library service for 'King's Well Walk, Cheltenham' (Catalogue Ref. Box A/PR2.9CE); p. 43 'J. Austen' courtesy Library of Congress; p. 45 Cheltenham Library service for 'Old Wells and Pump Room, Cheltenham' c. 1813 (Catalogue Ref. Box A/PR3.3CE); p. 46 Cheltenham Library service for Thompson's 'Montpellier Spa' (Catalogue Ref. Box A/PR5.2CE); p. 48 (top) 'Eccentrics in High Street, Cheltenham', by Robert Cruickshank © Private collection; p. 48 (bottom) 'The Bags Men's Banquet at the Bell Inn Cheltenham, by Robert Cruickshank © Private collection; p. 49 (top) 'The Royal Wells Cheltenham or Spasmodic Affections from Spa Waters' by Robert Cruickshank © Private collection; p. 49 (bottom) 'Going Out: View of Berkeley Hunt Kennel' by Robert Cruickshank © Private collection; p. 50 The Headmaster, Cheltenham College, for 'Principal Entrance to Bayshill & The Proprietary School'; p. 51 (top) 'The Rapid Effects of the Cheltenham Waters', by 'Giles Grinagain', 1818 © Cheltenham Art Gallery & Museum; p. 51 (bottom) Cheltenham Library service for 'West End of Sherborne Pump Room, Cheltenham' (Catalogue Ref. Box B/PR10.4CE); p. 52 (top) 'Mr Jorrocks's Return to his Family' by John Leech © Private collection; (bottom) 'Mr Jorrocks enters into Handley Cross' by John Leech © Private collection; p. 53 Title page to *Vanity Fair* drawn by W. M. Thackeray is reproduced as a public domain image from Wikimedia Commons; p. 54 Engraving on wood by W. M. Thackeray for the first edition of *The Book of Snobs*. Chapter III: 'Our children are brought up to respect the Peerage as the Englishman's second Bible' is reproduced as a public domain image from Wikimedia Commons; p. 55 'Miss Matty and her brother Peter' by Sybil Hawse from *Cranford* is reproduced as a public domain image from Wikimedia Commons; p. 56 'Dinah Maria Mulloch Craik', wood engraving from *Belford's Annual 1888-9 Animal Sketches for Children* (1894) © Private collection; p. 58 'Gustavus Jelly, Esq.' by Harry Furniss from *Mrs Montague Jones' Dinner Party: or, Reminiscences of Cheltenham Life and Manners* © Private collection; p. 60 (top and bottom). Drawings by Fougasse from *Godfrey Marten, Schoolboy* © Kenneth Cyril Bird (1887–1965); p. 61 The Headmaster, Cheltenham College, for 'Cheltenham College'; p. 62 (top and bottom) The Headmaster, Cheltenham College, for 'Big Classical, Cheltenham College', c. 1890 and 'Boyne House sweat room'; p. 63 The Headmaster, Cheltenham College (top) for 'Cheltenham College in 1850' (bottom) for 'Cheltenham College in 1950'; p. 64 The Principal, Cheltenham Ladies' College, for 'Dorothea Beale' (1831–1906) by Anna Lee Merritt, 1893; p. 65 The Principal, Cheltenham Ladies' College, for 'Lilian Faithfull' (1865–1952) by Gerald Kelly, 1922; p. 66 'Elizabeth Gillard outside 5 Suffolk Square' © Elizabeth Gillard; p. 68 (top and bottom) P. J. Crook for 'The Transaction' by P. J. Crook (private collection) and 'Waiting for the big race' by P. J. Crook (private collection); p. 69 (top and bottom) © Cheltenham Racecourse; p. 70 (top and bottom) © Cheltenham Racecourse; p. 71 (top and bottom) © Cheltenham Racecourse; p. 72 (top and bottom) P. J. Crook for 'The Jockeys' Changing Room' by P. J. Crook (collection Cheltenham Racecourse) and 'A Day at the Race' by P. J. Crook (private collection); p. 73 (top) P. J. Crook for 'Big Race' by P. J. Crook (collection Drs C. & E. Slosberg); The New Club, Cheltenham for 'Gilbert Jessop (1874–1955)'; p. 75 (top and bottom) Peter James for 'New Club Tent, Cheltenham College, July 2000', by Peter James and 'Cheltenham Cricket Festival' by Peter James; p. 76 (top) 'Cheltenham

Croquet Club Boardroom' © Keith Davis; p. 78 'Programme of 'Lansdown Castle'' © Cheltenham Art Gallery & Museum/The Holst Birthplace Museum; 'George Frideric Handel' by John Faber Jr, after Thomas Hudson. Mezzotint, published 1749 © The Handel House Collections Trust; p. 81 'Interior of Music Room, Holst Birthplace Museum' © The Holst Birthplace Museum; p. 82 'Portrait of Gustav Holst' by William Rothenstein, 1921 © The Holst Birthplace Museum; p. 86 The Principal, Cheltenham Ladies' College, for 'Cavendish House advert, 1913'; p. 87 (bottom) 'A Sweep's trade sign, Cheltenham, about 1840–50' © Cheltenham Art Gallery & Museum; p. 88 © Private collection; p. 90 'The Cheltenham Potter in her Workshop' © Ann-Sohn Rethel; p. 92 'Huffkins Cheltenham Shop Front' © Josh Taee; p. 93 Images of the Cipher Stone at GCHQ, Cheltenham, Crown Copyright, reproduced with permission of Director, GCHQ; p. 94 (top) 'Foreign Secretary, Rt Hon. William Hague, MP, with former Chief of the Secret Intelligence Service, Sir John Scarlett, at Bletchley Park, 18 October 2012' Crown Copyright; p. 94 (bottom) 'GCHQ's New Building' (The Doughnut), Crown Copyright, reproduced with permission of Director, GCHQ. All other images are reproduced © David Elder.

Literary Extracts Credits

I am most grateful to the following for granting me kind permission to reproduce extracts from copyright material. p. 6 *The Road to Wigan Pier* by George Orwell (Copyright © George Orwell, 1937), reprinted by permission of A. M. Heath & Co. Ltd. p. 6 'Cheltenham: a Regency Town', copyright Hugh Casson, reproduced/reprinted with permission of the estate of Hugh Casson. p. 6 *Down Cheltenham Way*. Foreword by U. A. Fanthorpe reprinted with permission of Dr R. V. Bailey. p. 9 *Village Wooing* by G. B. Shaw, reprinted by permission of The Society of Authors, on behalf of the Bernard Shaw Estate. p. 11 *Howard's End* by E. M. Forster, reprinted by permission of The Society of Authors. p. 11 Gustav Holst letter, 1927. Permission granted by the Holst Foundation. p. 12 *English Cities and Small Towns*, © John Betjeman, by permission of The Estate of John Betjeman. p. 12 *Report on Cheltenham*, reprinted by permission of The Georgian Group. p. 13 *Jack Robinson* by George Beaton. Permission granted by The Hanbury Agency. p. 12 *Hand in Glove*, by Robert Goddard, published by Bantam Press. Reprinted by permission of The Random House Group Limited. p. 15 *The Tale of a Cheltenham Lady*, by Elizabeth Gillard. Permission granted by the author. p. 16 Extract from *Buried Day* by C. Day-Lewis is reprinted by permission of Peters Fraser & Dunlop (www.petersfraserdunlop.com) on behalf of the Estate of C. Day-Lewis. p. 17 *Lestrade and the Gift of the Prince*, and *Lestrade and the Guardian Angel*, by M. J. Trow, published by Constable, reprinted by permission from Andrew Lownie. p. 19 Extract from 'Naked in Cheltenham or the Music Will Never Stop' by Adrian Mitchell reprinted by permission of Peters Fraser & Dunlop (www.petersfraserdunlop.com) on behalf of the Estate of Adrian Mitchell. p. 21 *Loser Takes All* by Graham Greene, published by Vintage, Random House. Permission granted by David Higham Associates. p. 21 'Nice People' by Penelope Lively, published by Penguin in *Pack of Cards: stories 1978–1986* is reproduced by permission of David Higham Associates. p. 22 *The Diary of Virginia Woolf*, reprinted by permission of The Random House Group Ltd. p. 22 Extract from 'Naked in Cheltenham or the Music Will Never Stop' by Adrian Mitchell reprinted by permission of Peters Fraser & Dunlop (www.petersfraserdunlop.com) on behalf of the Estate of Adrian Mitchell. p. 31 Josephine Butler letter, 1902, reproduced by permission of The University of Liverpool Library. p. 36 'Cheltenham Clerihews' by Peter Wyton, reproduced by permission from the author. p. 39 Ann Yearsley, 'To The King On His Majesty's Arrival at Cheltenham 1788', ed. Moira Ferguson, *Tulsa Studies in Women's Literature*, 12:1 (Spring 1993), 37–39. Original manuscript housed in Bristol Public Library. p. 39 *Princesses: The Daughters of George III* by Flora Fraser (Bloomsbury Publishing, 2012): 6 Fear. Loc. 2095 reproduced by permission. p. 40 *The Mysterious Maid-Servant* by Barbara Cartland. Permission granted by Cartland promotions and Rupert Crew Limited. p. 41 Johanna Schopenhauer, *Reise durch England und Schottland*. Translated from the German by David Elder and Claudia Seidel. p. 44 'Lines Extempore on Taking My Last Farewell of the Statue of Hygeia at Cheltenham' by Elizabeth Barrett Browning is reproduced by permission of Pickering & Chatto Publishers. p. 45 *Bird's Eye View* © John Betjeman by permission of The Estate of John Betjeman. p. 46 'On Thompson's Spas Cheltenham' by Elizabeth Barrett Browning is reproduced by permission of Pickering & Chatto Publishers. p. 62 *The Old School Tie*, © Arthur Tuckerman, 1954. p. 62 *Flaws in the Glass: a Self Portrait* by Patrick White, published by Jonathan Cape, is reprinted by permission of The Random House Group Ltd and Barbara Mobbs. p. 63 Extract from *Buried Day* by C. Day-Lewis is reprinted by permission of Peters Fraser & Dunlop (www.petersfraserdunlop.com) on behalf of the Estate of C. Day-Lewis. p. 66 *The Tale of a Cheltenham Lady*, by Elizabeth Gillard. Permission granted by the author. p. 70 'They're Off!' by Robert Benchley reprinted by permission of Nat Benchley. p. 71 *Outside Chance* by Lyndon Stacey reprinted by permission of The Random House Group Ltd. p. 72 *A Year in the Cotswolds* by John Hudson. Permission granted by the author. p. 73 'Dawn Run' by Henry Birtles. Permission granted by the author. p. 75 P. G. Wodehouse Letter to R. V. Ryder. Permission granted by the Edgbaston Cricket Ground Museum, Warwickshire County Cricket Club. p. 76 *Impudence of Youth*, by Warwick Deeping is reproduced by permission of Eric Glass Ltd. p. 76 *Hitched* by Zoë Barnes is reprinted by permission of the Tanja Howarth Literary Agency. p. 80 *38 Priory Street (and All That Jazz)*, © John Appleby, 1971. p. 81 *The Music of Gustav Holst* by Imogen Holst. Permission granted by the Holst Foundation. p. 82 Gustav Holst letter, 1924. Permission granted by the Holst Foundation. p. 83 *Gustav Holst: a Biography* by Imogen Holst. Permission granted by the Holst Foundation. p. 84 'A Tribute to Brian Jones' by Rob Weingartner is reproduced by permission from the author. p. 85 *As I Walked Out One Midsummer Morning* reproduced with permission of Curtis Brown Group Ltd, London on behalf of the Partners of the Literary Estate of Laurie Lee. Copyright © Laurie Lee, 1969. p. 86 *Return to Cheltenham* by Helen Ashton is reproduced by a contact provided by the WATCH Office, University of Reading. p. 87 'The Chimney-Sweeps of Cheltenham' by Alfred Noyes is reprinted by permission of The Society of Authors as the Literary Representative of the Estate of Alfred Noyes. p. 88 *A Life of One's Own* by Gerald Brenan is reproduced by permission from The Hanbury Agency. p. 89 *Cider with Rosie* by Laurie Lee is reprinted by permission of The Random House Group Ltd and by permission of David R. Godine, Publisher, Inc. Copyright © 1980 by Laurie Lee, 1959. p. 90 *Corduroy Mansions* by Alexander McCall Smith, published by Polygon, is reproduced by permission from David Higham Associates Ltd.

While every effort has been made to contact relevant copyright owners, if there are any omissions the author will be pleased to make the necessary arrangements to rectify these at the first opportunity.